WEDDING PHOTOGRAPHY

CREATIVE TECHNIQUES FOR LIGHTING AND POSING

2nd Edition

Rick Ferro

AMHERST MEDIA, INC. ■ BUFFALO, NY

ACKNOWLEDGEMENTS

It is always a goal for a photographer to have his or her work published and Craig Alesse has made one of my dreams come true ... thank you so much, Craig.

There are many more people to thank. First, let me thank K&K Video and Film Productions for letting me contract for this book, despite our busy schedule. I would like to thank the Fort Lauderdale Institute, especially Mr. Ed. Williams and Mr. Bill Barhart. Also a special thanks to my printers, Katherine Schutt and Tammy Alexander — excellent job!

Thanks go also to my special mentor, Monte Zucker, and to Don Blair, who showed me the light. I'd like also to thank my family in Cranston, Rhode Island, for being there when I graduated and throughout my career. Last but not least, thanks to the Lord for giving me this gift of painting with light.

Copyright ©2001 by Rick Ferro.
All photographs from Signature Series by Rick Ferro, Inc.
All rights reserved.

Published by:
Amherst Media, Inc.
P.O. Box 586
Buffalo, N.Y. 14226
Fax: 716-874-4508

Publisher: Craig Alesse
Senior Editor/Project Manager: Michelle Perkins

ISBN: 1-58428-046-8
Library of Congress Card Catalog Number: 00-133611

Printed in Korea.
10 9 8 7 6 5 4 3 2 1

TABLE OF CONTENTS

CHAPTER 4
━━━━ THE WEDDING PARTY AND FAMILY ━━━━

CHAPTER 5
━━━━━━ CREATIVE TECHNIQUES ━━━━━━

APPENDIX

Before I started writing this book, I picked up a few wedding photography books. Some were interesting, but many started by asking you to read chapters like "What is a Wedding?" or "What Equipment You Should Use," or even titles to the effect of "Check out Our Great Photos of the First Dance at the Reception." This book is not like those. Instead, I wanted to reach out to the photographers who plan ahead, and work hard to deliver the wedding album of their clients' dreams.

Beginning with pre-wedding planning, you'll learn how to guide your clients through all the steps of photographing their wedding. Next, you'll see how to create beautiful studio portraits of the bride. Chapter two explores portraiture of the bride and groom on their wedding day, covering shots of the ceremony, posed images in the church, and environmental shots. Chapter three expands to cover techniques for photographing the couple with their attendants and family. Techniques for lighting and posing groups are discussed. Chapter four explores special photographic techniques you'll want to consider adding to your repertoire. Throughout the book, special attention is paid to techniques for lighting and posing for exciting wedding

portraiture. Clear diagrams and easy to read text accompany each image.

Wedding photography is a challenging field that demands creativity and style. This book will help you gain the knowledge and flexibility you need to achieve images that will make you proud and set you apart from the crowd.

■ About the Author

Rick Ferro is a professional photographer who served as the Senior Wedding Photographer at Walt Disney World from 1993-1996. In his twenty years as a professional photographer, Rick has shot over 10,000 weddings and owned three studios. Some of his clients have included Pepsi, Sprint, Lexus, the Miami Dolphins, Regis & Kathy Lee, and American Express. Rick's creative and dramatic wedding images have appeared in *Bridal Magazine*, and have won awards in regional and national competition. He is currently the Director of Photography for K&K Video and Film Productions in Orlando, where his responsibilities cover their locations in Florida, Las Vegas and Hawaii.

BEFORE THE WEDDING

A very important factor in successful wedding photography is how well you and your clients plan for the shoot. A very coordinated and guided approach will ensure that the couple's wedding album is exactly what they wanted, and help guarantee that the shoot runs smoothly and is fun for your clients.

A meeting with the client to discuss planning before the wedding is essential. We invite our clients to the studio and work with them to lay out plans for the day. Although we have specific needs (in terms of time, etc.), we make sure not to make the clients think that they will have to do it our way. Rather, we make it clear that this is their special event. We want to work with them to make sure not only that the day is wonderful, but also that they have the images they want to remind them of it.

Pre-wedding consultation with your client will naturally include planning and scheduling for the wedding day. Images in the church and of the ceremony are extremely important and should be covered in detail to ensure that you don't miss an image the couple wanted. You'll also want to discuss locations other than the church at which the couple would like to shoot. These environmental portraits offer you a unique opportunity to capture the style and romance of the happy couple. Having a few favorite locations to recommend to clients can be very helpful.

When you sit down with your clients, you'll also want to be sure to discuss pre-wedding images in the studio. Since make-up and hair-styling is an important part of this step in the photographic process, we usually ask our stylist to sit in on the conversation at this point. This helps the client feel comfortable when they later arrive for their studio session, and ensures that we all have the same goals in mind for the shoot.

About three weeks before the wedding, we invite the bride to come to the studio for her portraits. Our goal is to come up with twelve different images. These will vary from full length, high key portraits, to head and shoulder, low key images. The images should be elegant, and display the bride's natural beauty. Capturing the look of the bride is an important part of the wedding photographer's job, since these images are very important to the success of the wedding album. The rest of this chapter will be devoted to the techniques needed to create dramatic studio wedding portraits.

Pre-ceremony group images on the wedding day should also be discussed. Turn to page 100 for more information on this important topic. Below is a list of suggested topics to cover in your pre-wedding discussions with clients. You may also wish to refer to the checklist of poses and groupings on page 117.

■ PRE-WEDDING CONSULTATION CHECKLIST ■

A pre-wedding consultation with the couple is crucial to a smooth and successful shoot on the wedding day, as well as for pre-wedding studio portraits. Below is a checklist you may wish to use to ensure you cover all the necessary topics at every consultation.

1. Create a comfortable, friendly and professional atmosphere. Serve refreshments. Clients will be spending a lot on money on your services; make them feel appreciated.
2. Confirm dates, times, locations and schedule for the wedding day.
3. Record the phone numbers and addresses of the bride, groom and parents.
4. Discuss pre-wedding studio portraiture (including engagement portraits) and invite the bride to come to the studio three weeks before the wedding for a photo session.
5. Create a list of "special shots" to add to the list of standard shots you normally take. This could include special family members, friends, etc.
6. Discuss environmental photos to be taken on the wedding day.
7. Discuss the system of photographs and the shot list included on page 117.

Kari Larsen is our make-up artist and hair stylist. She suggests these guidelines on make-up for bridal photography:

When doing photographic make-up you must know what look the photographer and client are going for – natural, semi-natural, dramatic or very dramatic. You must also keep in mind the film that will be used. Make-up application differs for black & white and color film.

■ Color Film

For this film, you'll want the end results to look perfectly blended and flawless. Select colors to naturally enhance the beauty and shape of the bride's eyes, lips, and bone structure. Since the colors will appear more muted on film than to the human eye, makeup should be enhanced to one or two shades deeper than for day wear.

For eyes, avoid too much color. I always choose neutral tones which enhance without being too visible. I start with an overall color (like cream) then use darker colors for shading. Blend the colors well and carefully. Remember, we want to see the subject, not the makeup. For lips, select a color to compliment the subjects eyes and hair. Either a glossy or matte finish can be appropriate, depending on the look you want. Glossy lips are great for dramatic images, matte lips look more natural. For

cheeks, I tend to use very little color – just enough to enhance the bone structure. After applying a little color, I blend it in with a sponge to soften it. To finish the look, I go over the entire face with my sponge, then use a translucent face powder to eliminate all shine.

■ Black & White Film

Make up looks much more muted with black & white film than with color. What would look very dramatic in color, will look merely natural in black & white, and what would look natural in color, will look drowned out in black & white. Therefore, you need to apply the makeup much more heavily for black & white than for color. Warn the subject that, although her make-up may feel caked on, it will look great in the photos.

Application should proceed the same way as for color film, but remember that color will not show up, so you need only worry about shading and highlighting.

■ Both in One Sitting

It's easier to add make-up than remove it, so going from a natural look color to a natural look in black & white is usually easier than the reverse. The key is good communication with the photographer, and making sure you both know what the outcome is going to be.

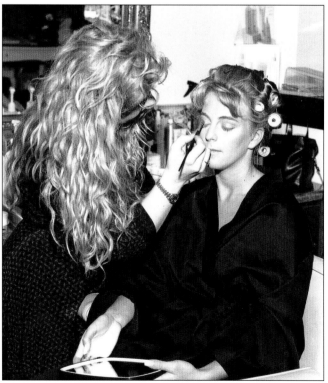

Hair and make-up by Petra.

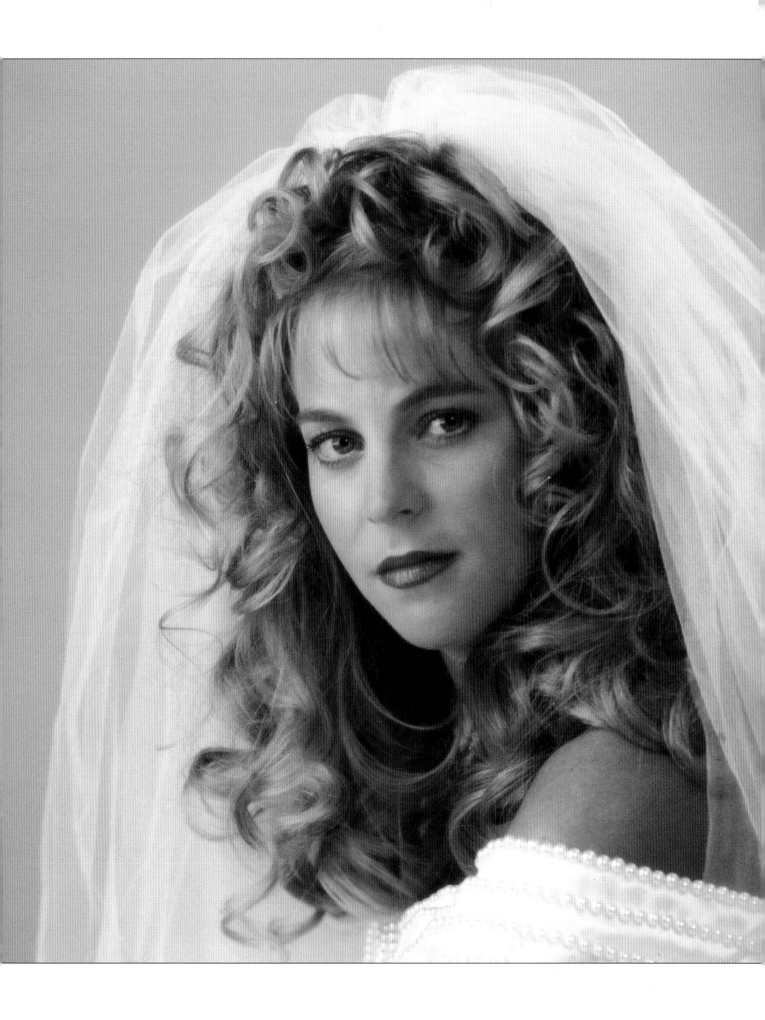

■ Soft Focus Filters

Soft focus filters are something I use very frequently. I rely on the Tiffen Soft Net (numbers 2, 3, and 5), and also find the Black Net filter (numbers 2 and 5) to be very good. Soft focus filters make a world of difference in the female subject's complexion, softening the skin, diminishing the appearance of lines and blemishes and creating an overall soft and dramatic look.

The image on the facing page shows a medium amount of softening. For comparison, flip to the image on the previous page to see the same image without soft focus. As you can see, the difference is dramatic. Soft focus is a popular look among brides, and a look you should be sure to capture in at least a few shots.

■ Lighting

The lighting for this image was simple. The main light was placed in a large soft box to the bride's right. An umbrella with reflective interior surface was placed over the camera. A snoot, a light I like for the good control it allows, was placed over the bride as a hair light.

To adjust this light properly, begin with only the hair light, positioning and setting it appropriately. Next, add the soft box and position it to create a Rembrandt pattern on the bride's face. This lighting pattern lights the subject's face from a 45° angle and creates strong shadows that add depth and shape to the model's face. Adjust the soft box to create the proper lighting ratio. Lastly, add the umbrella and set it one stop lower than the main light.

■ More on the Pre-Wedding Consultation

When you have prospective clients in for a pre-wedding consultation, you should create an atmosphere in your studio that is cordial, comfortable and professional. You should also dress for success – making sure you are well groomed and dressed neatly. Be well prepared for every meeting. You need to be sure of your prices, and prepared to talk about things your clients won't even have thought about, like the benefits of no-flash photography during the ceremony, the importance of time and scheduling on the wedding day, and even the shot list and system of photographs (as on page 117).

When our guests arrive, the last place we take them is the consultation room. Why? We don't want to get into the expenses just yet. Instead, we take them on a tour of the facility. First, we show them the studio. This lets them know that we are not just wedding photographers, but experienced professionals in all aspects of the field. Next, we walk them down our "Hall of Fame" where we display some of our best work. Don't be afraid to flaunt your previous accomplishments and show clients the kind of work they can expect from you. Explain the awards you've won, and show them some of your favorite pictures. If you've shot at their church or wedding site before, be sure to point out those images.

Notice, we have still not talked about prices, only the quality of our work. Next, we move on to the consultation room. One of the next things we discuss is what kind of photographer the client is looking for. When you ask this, be prepared for your clients to look at each other with a puzzled expression. They probably won't know what you mean. We then explain our style of photography. We love to produce a love story, starting with an engagement photo, then an elaborate bridal photo session with hair and make-up, then photography at the wedding. We like our albums to contain not only traditional photos, but some panoramic pages, some black & white photos, and some handcolored images.

Still, we do not discuss prices. Instead, we sit with the clients and go through sample albums, folios and gifts items. We control the sample album, turning the pages and explaining the images. Get involved and be enthusiastic. Most of all, don't be in a hurry. We sometimes spend as much as two or three hours discussing the wedding day with our clients. When you are done looking at the albums, it's finally time to discuss prices and packages.

I don't go into much more detail at this point because I want to give the clients some time to review what we have already discussed. By the time we've finished our conversation, clients know that we are not just an average studio, but a studio that wants them to be educated consumers.

■ Follow Up

Within a week after our consultation, we send the clients a gift box of wallet-sized images of some of our special weddings, and a congratulation card. We then follow up with them by phone in about two weeks.

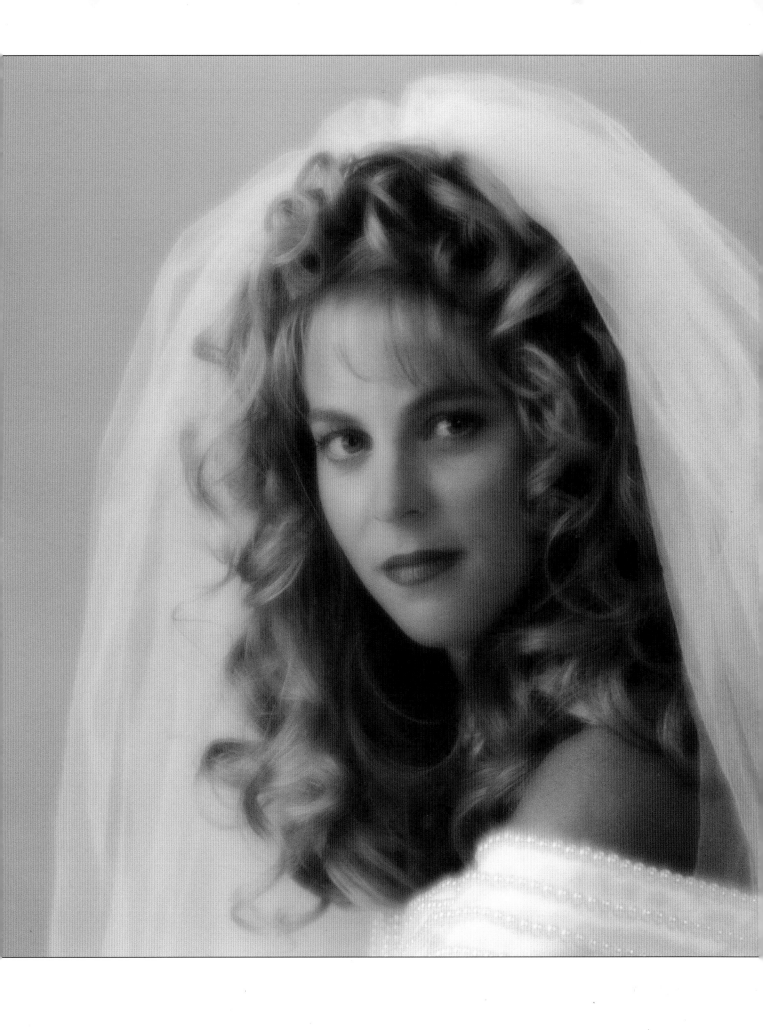

■ Veil as Backdrop

A beautifully simple backdrop for a bride is her own veil. We use this technique in the studio, but also on location – usually on the staircase of the church. My assistant and someone from the bridal party simply hold the train up high to create a backdrop. Its an easy method that works, and one I urge you to try.

■ Hand Posing

What do you do with hand posing to create a dramatic look? The photos on the opposite page show some simple, yet elegant answers to that question. As you can see, even without changing the lights, camera position, or background, you can create a series of very unique portraits simply by moving the model's hands.

■ Camera Position

Another important element which helps give this series of portraits their unique flavor is the fact that I shot them all from a ladder. Buying yourself a small step ladder is a good investment that will allow you a simple way to get a new angle on your portraiture.

■ Composition

You'll notice that I rarely place the subject in the center of my portraits. It could be tempting to do this, especially since the subject is the whole reason for taking the portrait in the first place. Still, compositions that encourage the viewer's eye to move across the image (rather than letting it freeze dead center) are ultimately more compelling and more interesting to look at.

■ Awards

The top, right hand photo on the opposite page is called "Solitude," and has won many awards, including a merit at the 1998 Professional Photographer's of America convention in New Orleans. It has also appeared on the cover of *Rangefinder* magazine.

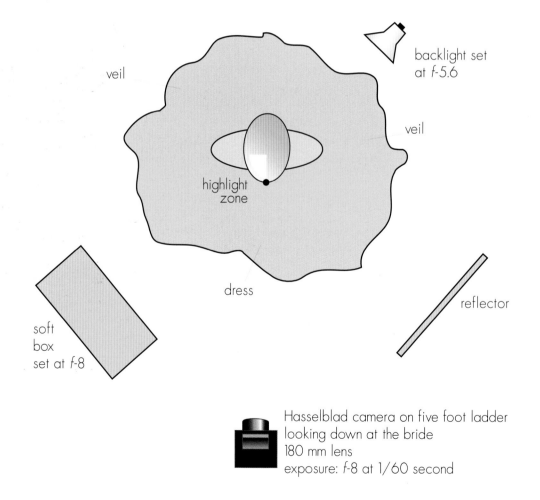

veil

backlight set at *f*-5.6

veil

highlight zone

dress

reflector

soft box set at *f*-8

Hasselblad camera on five foot ladder looking down at the bride
180 mm lens
exposure: *f*-8 at 1/60 second

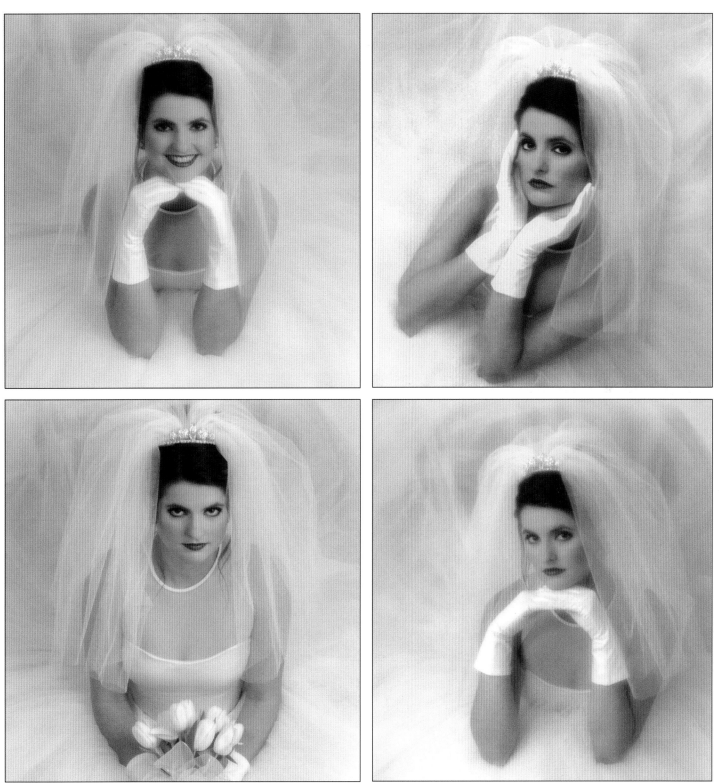

◼ Getting Started

Training is vital to a successful career in photography. There are many ways to develop the skills you need, and many chances to learn and further develop those you already have. Even if you graduate with a photography degree, your training in the real world continues every day. I believe it takes years to really "see the light."

Join your local photography organizations. They always have something going on – whether a meeting or a seminar. These organizations can be a great help as you get your career under way and work as a professional. Some groups, like the Professional Photographers of America, also have monthly publications loaded with helpful ideas and information. There are also many books and videos available that can help you achieve the results you want. Classes are an especially great way to learn photography, and I would advise you take advantage of as many of these as you can afford.

Photography is a never-ending art, and the effort you put into learning the professional techniques of the craft will pay off exponentially.

◼ Lighting

A low key image like this is a nice addition to a bridal album, and I make sure to shoot some low key images during every bridal portrait session. I like to keep the lighting as simple as possible and make an exposure at about f-8 or f-11. Metering for this image was done close to the face to ensure that it would be properly exposed, and that the background would go totally black. The main light was placed to the left side to create shadow detail. An umbrella was used over the camera, and a hair light was added above the subject to highlight her hair.

◼ Posing

After the bride's hair and make-up had been expertly styled, we shot a series of poses including this ³/₄ pose and the profile on page 17. Notice in the profile how the subtle edge lighting helps to separate the subject from the background.

For the image on page 16, I tried another technique. I wrapped the bride's face in different parts of her dress – you'd be surprised at the number of very different looks you can achieve!

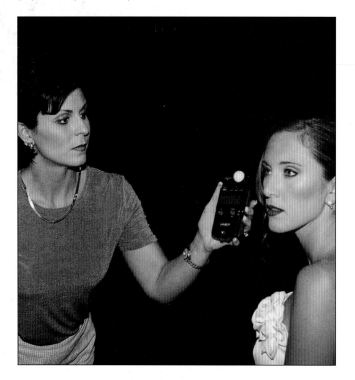

Above: *Metering for the portrait was done near the subject's face.*
Right: *In the studio, an assistant perfects the bride's make-up.*

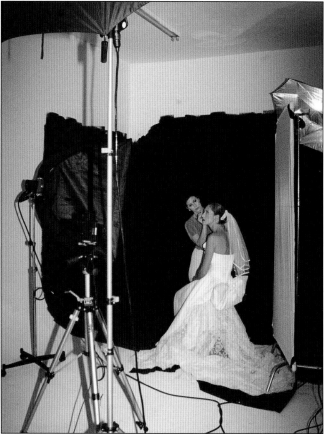

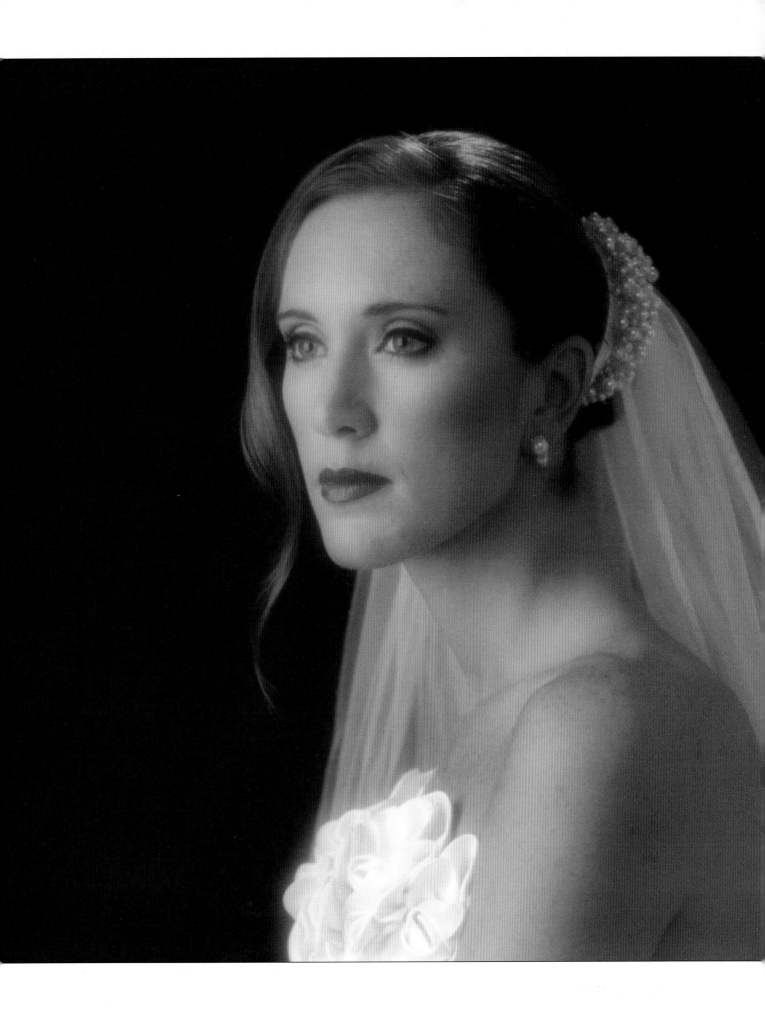

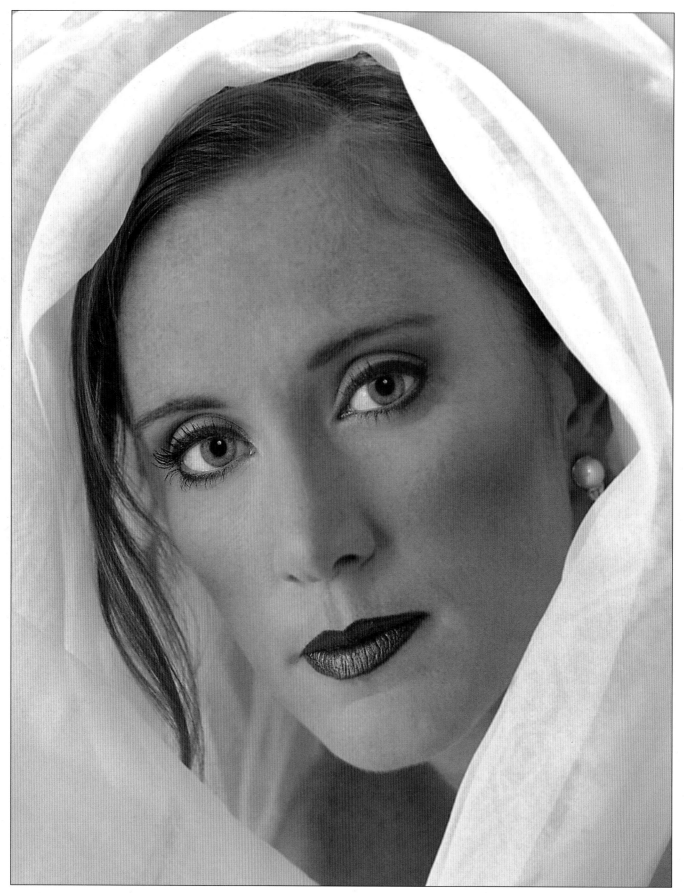

Above: *When shooting close-ups with a ²/₃ pose (whether of a bride or a groom), I follow a simple rule for posing. When turning the subject's face, I make sure to leave about ¹/₄ inch of the face showing beyond the far eye. Another simple rule for setting up a ²/₃ view of the face for close-ups is to turn the subject's head until his or her ear just disappears.*

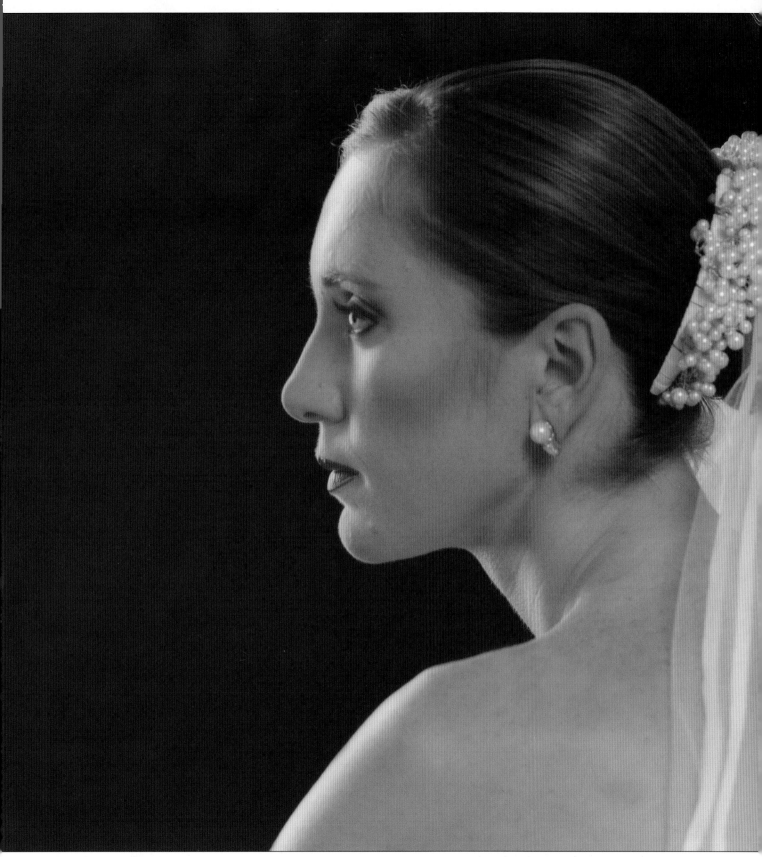

Above: *For this elegant profile, there are a few things to keep in mind. First, you must pose the subject for a complete profile. Anything else will not create the proper lighting pattern. The light must come in at a 45° angle and quite high. Here, the main light source was a soft box placed to the left of the subject and back to create the lighting pattern you see on the bridge of her nose and the triangle of shadow on her face. This is called a Rembrandt lighting pattern.*

◼ Getting Started in Wedding Photography

All studios try to compete with each other. Fortunately, we have developed a style that sets us apart. We call it "Love Story" photography. Whatever your own style, and whether you do photography part-time or are a dedicated art photography professional, you have to deal with the business of the field. To get started, you should prepare for a substantial investment in equipment, energy and time.

◼ Training

Fortunately, there are endless programs, seminars, organizations (both national and local) as well as books and videos to help you succeed. A great way to start is by donating your time as a weekend assistant to an established wedding photographer. Better yet, try to assist several photographers, so you'll benefit from the variety of their skills and experiences. This will also give you training with a variety of equipment.

◼ Portfolio

To sell your skills, you'll need a portfolio of wedding images. If you assist another photographer, he or she may allow you to shoot a few candids at a wedding. Also, consider introducing yourself to a local bridal shop and asking to borrow some of their gowns to do some samples for them. If they consent, find a model and take her out into the field with this book. Don't try to learn everything, but rather focus on one pose at a time and learn it well.

You may also be able to secure permission to shoot in a church during the week. Then return to the bridal shop with a few great prints as trade and leave them your card. This is a great way to get started.

As you increase your skill and business, you may wish to compile several portfolios to match the varying budgets of your clientele. If you decide to open your own studio, you should also plan to invest in professional framing and a few canvas prints. This will tell your clients that you are professional and that they will be happy with your work.

◼ Pricing

You must think through and establish a game plan so you won't need to hesitate when clients ask for a price. For a new photographer, the most important thing to keep in mind is your cost. Make sure to figure your film, processing, batteries, assistants, the album, enlargements, insurance, square footage space you own or rent, travel expenses and your basic wage (plan on six to eight hours for a wedding).

◼ Packaging

Determine what kinds of packages will work for you. There are infinite variations. It's important to remember that whatever packages you offer, clients are ultimately paying for the quality, not the quantity, of your work. You need a lot of great images to fill an album, but not at the cost of quality.

Chapter

Two

THE CEREMONY

Portraits

at

the

Altar

■ **Meet the Minister**

The first thing I do when I arrive at the church is introduce myself to the minister. This is especially important if you have never worked at the church before. Regardless of the denomination, most churches will not allow you to use flash during the ceremony (remember, this is an important religious ceremony, not just a social event). I let the minister know I will not be using flash, and that, in fact, he will probably not even see me during the ceremony. Then I explain that I will need to do a few posed shots at the altar after the ceremony. These include a shot of the couple with the minister, a re-creation of the ring exchanges between the bride and groom, and a re-creation of the couple's first kiss as husband and wife.

■ **Flash Photography**

I do not like to take flash photos during the ceremony, as I think it takes away from the mood of the moment and distracts the audience. Instead I take my light meter along and use it. To work with the existing light within the church, I select Kodak ASA 1000 film. This gives me the ability to shoot a shorter exposure.

■ **Lenses**

I also shoot with several lenses during the course of the ceremony. The image on the opposite page was shot with a 180mm lens. This is long enough to let me shoot from a discreet distance and fill up the frame nicely. I try to shoot four or five images from the balcony of the church (if there is one), then move down to the floor of the church and shoot from behind the guests.

■ **The Church**

When working in a church that is not particularly attractive, I am particularly careful with the lighting I use during the posed shots on the stage after the ceremony. If the altar is very dark, I may add light to it to give the images some flair. I also try out a variety of lenses. I may even backlight the bride and groom at the altar to create some silhouettes.

CEREMONY PHOTO LIST

The list below gives you some examples of the shots you should try to get as they are happening during the ceremony. A full checklist of shots to get throughout the wedding is included in Appendix I of this book.

1. Parents coming down the aisle
2. Parents lighting candles
3. Each bridesmaid (separately)
4. Flower girl
5. Ring bearer
6. Bride and Dad before they walk down the aisle
7. Bride coming down the aisle
8. Bride kissing dad on altar
9. For Jewish weddings, Mom and Dad kissing bride before giving her away

CEREMONY (SPECIAL PHOTOS)

This list suggests some wonderful additional shots you should definitely try to get once the ceremony is under way and the couple has arrived at the altar.

1. Full length images in back of church
2. Change lenses of existing light in ceremony
3. Go down to $^3/_4$ of aisle and repeat steps one and two.
4. Bride and groom lighting candles from back of church
5. Bride and groom kneeling, usually facing each other
6. Bride and groom kissing
7. Bride and groom returning down the aisle
8. Bride and groom returning down the aisle (have them kiss — a great shot!)

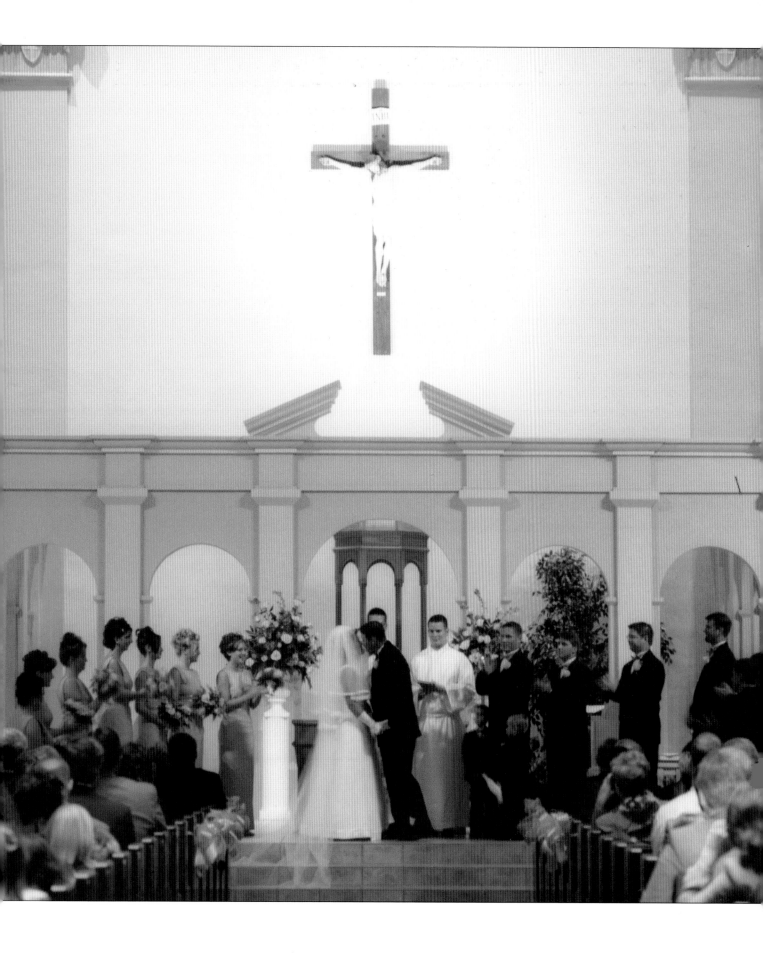

■ Variations in the Ceremony

Although the major elements of Jewish, Catholic and Protestant weddings are the same, you will be well advised to talk with your clients about the characteristics of the ceremony that is planned. This is especially true if you do not have a lot of experience shooting other such ceremonies. I have found, for example, that when shooting a Jewish wedding, I have very little time to shoot. I may only get an image or two during the ceremony and a quick return trip to the altar. However, the bride and groom usually don't mind seeing each other before the ceremony, so I can get a lot of their photography done at this time. I can usually also cover the family groupings before the couple's ceremony begins.

■ Communion

In the photograph on the opposite page, the couple is taking Communion during their ceremony in a Catholic church. This is one of the most sacred parts of the ceremony. Ninety percent of the time I do not even shoot it, but this church was quite lenient, so I was allowed to capture the moment.

■ Lighting

The major guideline to follow when shooting a ceremony is to be totally unobtrusive. Yes, the couples want great photos, but not at the expense of their ceremony.

This means never shooting with a flash, even if the church allows it, and not walking around during the ceremony. Take a few shots from the balcony, and a few from the back of the church, then wait until the ceremony is over and take the couple back to the altar to re-create the important parts of the ceremony. In addition to allowing the couple and their guests to experience the real ceremony without distraction, returning to the altar will also allow you to set up the important shots carefully, light them properly and create wonderful images.

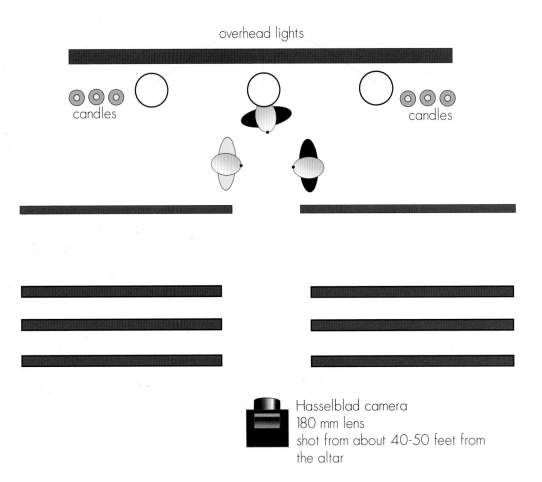

overhead lights

candles

candles

Hasselblad camera
180 mm lens
shot from about 40-50 feet from
the altar

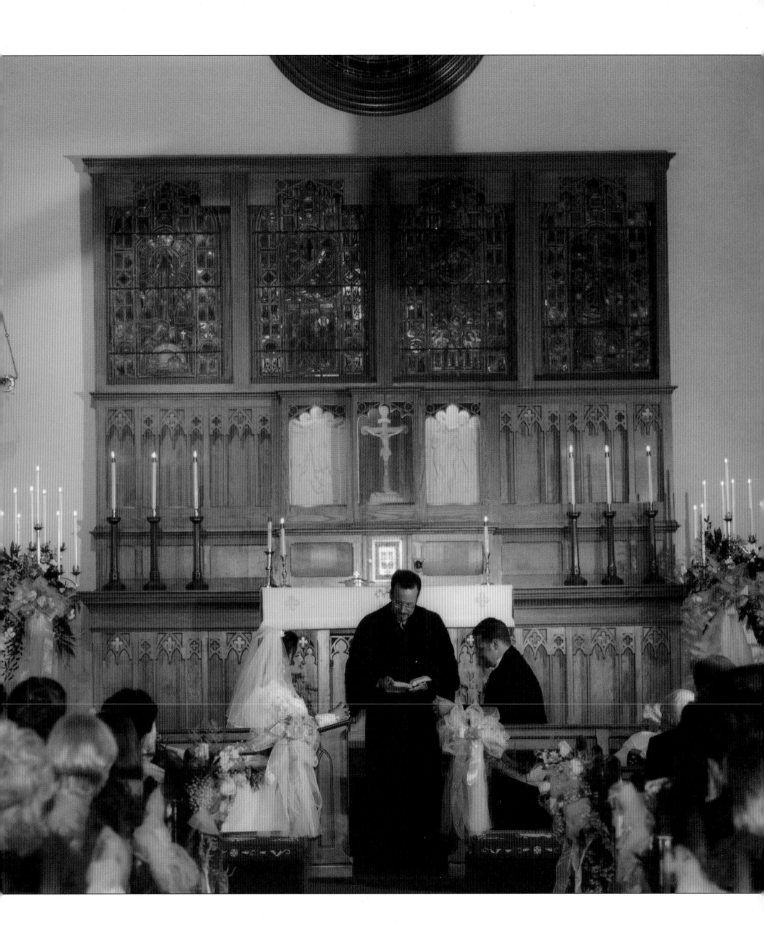

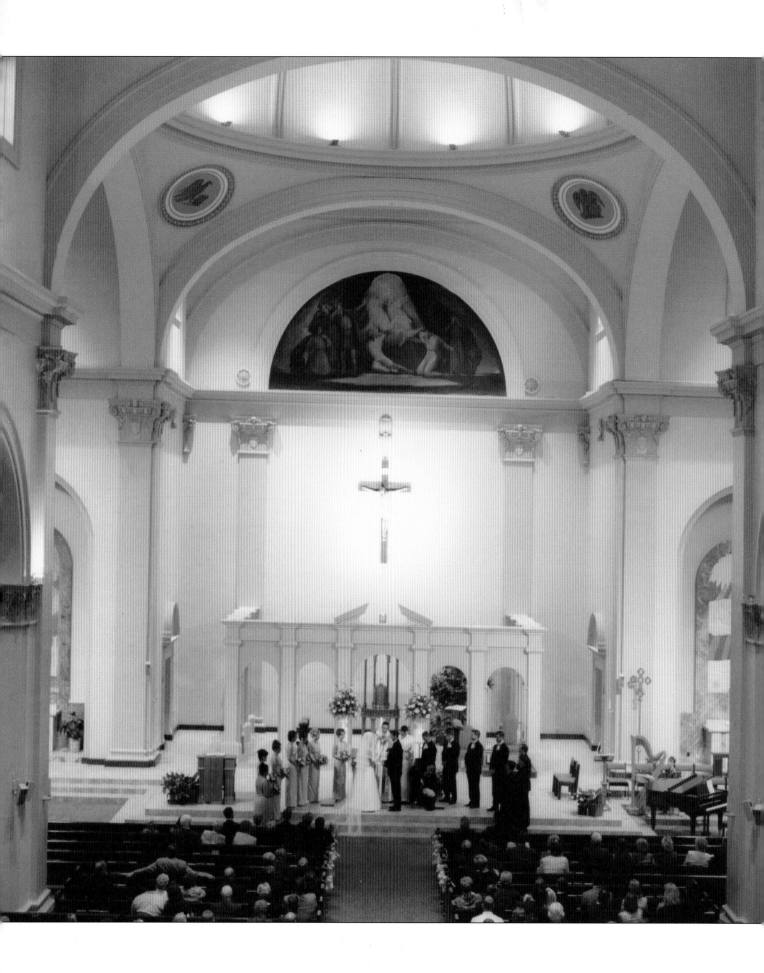

■ Architecture

When you are working in such a beautiful environment, you should capitalize on it in your images of the wedding. These vertical panorama shots are something we always include in the sample albums we show to clients in their consultation. They are very popular and a big seller.

■ Publicity

When you get a great panoramic image of a church, make an extra print and send it along to the church with your card. They will most likely display the image, often along with your card. This can be great publicity for you.

■ Getting the Shot

This image was shot during the opening ceremony of the wedding. Of course, my assistant and I were already set up with a camera and tripod in the balcony. We has also previously metered the altar area to be precisely sure of the correct exposure. We set up with high speed film (ASA1000, although I also like ASA 400 for such shots). This allowed us to comfortably shoot with the available light and not have to use an extremely long exposure.

We then waited until all the guests were seated and the wedding party had settled into their positions. Movement is something you just can't control, and can be a problem with the longer exposures needed for available light. To ensure that I get a usable image, I always shoot scenes like this four or five times.

■ Lens

I selected a 50mm lens for this shot. This allowed me to frame the highest dome of the church, and fill the frame using the first ten or twelve pews of the church. The basic rule of thumb for these shots? Keep the composition tight, and keep it simple.

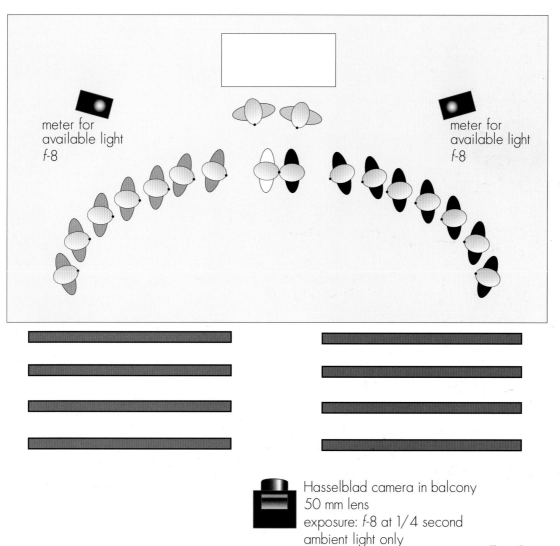

Hasselblad camera in balcony
50 mm lens
exposure: f-8 at 1/4 second
ambient light only

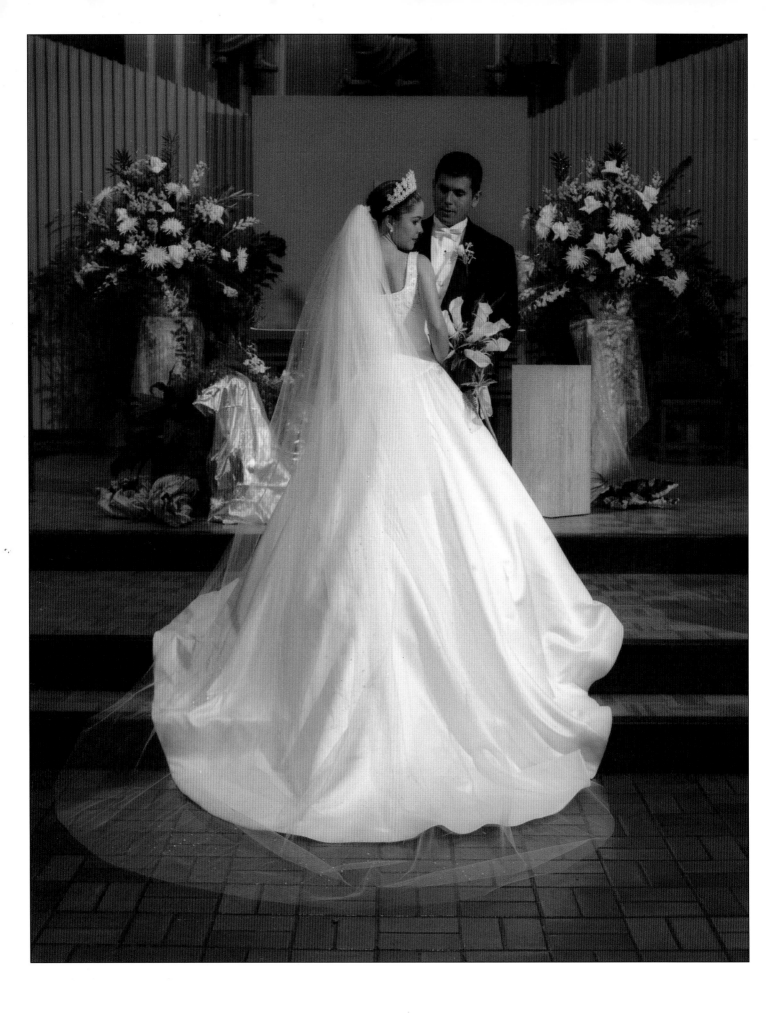

■ Return to the Altar

Don't get overly stressed out about trying to fully document every aspect of the ceremony as it happens. Rather, once the ceremony ends, have the couple and the minister return to the altar to recreate the desired scenes from the service. This will allow you a full range of camera positions and lighting options so you can get the shot just right. This is the best method for obtaining excellent images of the ceremony, since it allows you a full range of control.

■ Organization

Aside from images of the couple at the altar, as shown here, you should also be prepared to shoot a variety of images of the wedding party and family at the altar after the ceremony. A good plan is included on page 29.

■ Other Elements to Shoot

Especially if you are just starting out in wedding photography, I would advise getting to the church quite early and taking some shots. Set up a 3:1 light ratio and shoot close-ups of the altar, and special arrangements or flowers and candles on it. You'll also want to get shots of the decorations on the aisle of the church.

You may also want to do some set-up shots. Try taking a small table to a stained glass window (or regular window) and shooting a few arrangements of flowers (and or candles) using the window light.

One of the special shots we always do is of the candle that the bride and groom will light. To make it even more special, bring along one of the couple's wedding invitations and place it in front of the candle. Light the candle for a nice warm effect. Adding a star filter to this shot will give you another nice variation. One of these shots will make a perfect first page for the wedding album.

■ Marketing

Don't forget to make your images work for you! After the wedding, make a few extra prints of the photographs you shot of floral arrangements, and build a little album for the florist. Make sure to enclose your card, and present it to him or her. The florist can use your photos to sell his or her work to future clients, and may in turn be able to refer clients to you. This is a great way to get some exposure at a low cost to you. Brides often rely on the opinions and references they are given by professionals in the wedding business, so making sure that churches, florists, and bridal shops are familiar with your work can be extremely beneficial.

■ Timing

Most churches limit the time for formals to about thirty or forty minutes. When things are going well, this is sufficient, but many unexpected things can happen. If anyone is late, you'll have less time to shoot before the ceremony, and will have to squeeze these images into the time allotment after the ceremony. This is so important, we often offer the couple a $200 bonus to their package if they all arrive on time. This is an inexpensive insurance policy that will help you ensure you are able to get the precious images that are your responsibility.

■ Receiving Line

We try to discourage couples from having a receiving line for several reasons. First, occurring right after the ceremony, it cuts into the time for formals. Second, it opens up the opportunity for too many accidents – aunt Betty's make-up may get on the groom's shirt when they hug, the bride's make-up can be ruined, a high heel can accidentally go through the bride's dress, everyone may end up with lipstick on their cheeks, and if the weather is hot, everyone will be sweaty when they come back in for formals. Inform your clients, then let them decide.

RETURN TO THE ALTAR PHOTO LIST

The list below gives you some examples of the scenes you should recreate after the actual ceremony. A full checklist of shots to get throughout the wedding is included in Appendix I on page 117 of this book.

1. Reshoot some key images with flash
2. Bride and groom on either side of minister (full length and ¾ length)
3. Bride placing ring on groom
4. Groom placing ring on bride
5. Bride and groom kissing

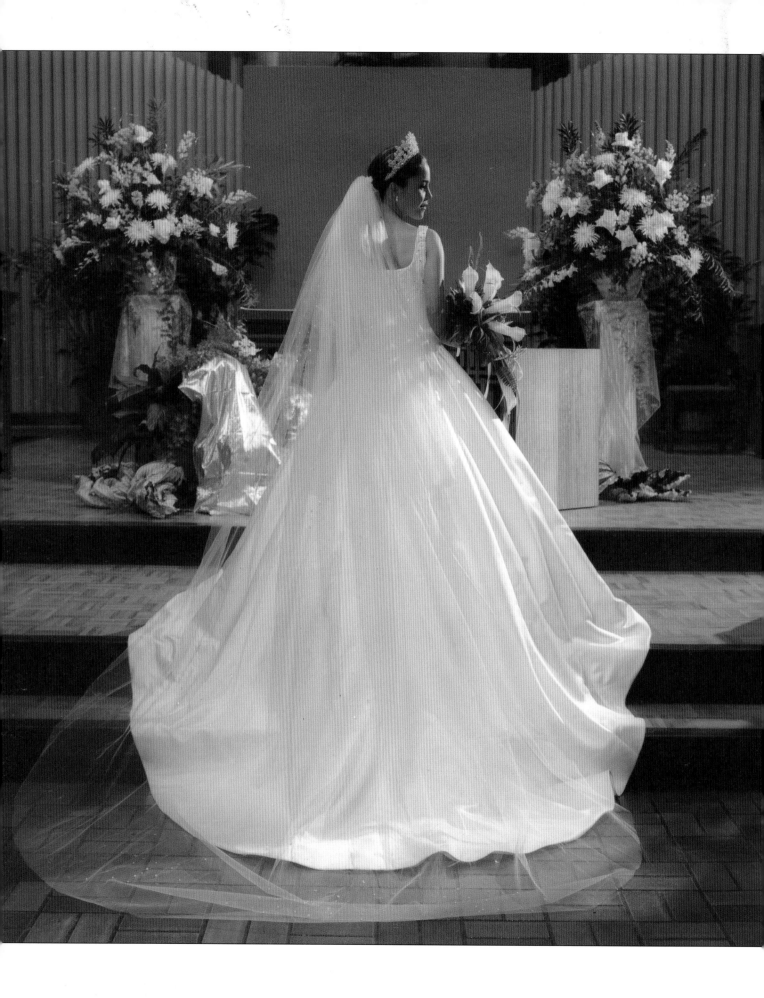

Once I've finished the set-up shots of the bride and groom at the altar, I move on to formal portraits of the bride, the groom, the attendants and the family. The next chapter will explore the lighting and posing of both of these subjects in more detail, dealing first with portraits of the bride and groom, next with images of the bride and groom with their attendants and families.

However, before diving into the photography it's good to have a plan of attack. You'll be dealing with a large number of people in a great variety of groupings, so moving them in and out of the scene efficiently and with a minimum of confusion will make the shoot much more enjoyable for both you and your subjects. If you stick to a regimented system, you'll also be surprised how quickly the shoot will move along.

■ Start with the Couple

I always start by shooting about three, full length images of the couple. Then I do the same shots, but in a $^3/_4$ length. Finally, I do the shots again, but with the couple looking at each other.

■ Couple with the Bride's Family

The next step is to start adding family members. I usually start with the bride's family. Start with the couple and her parents, then continue to add family members step-by-step: brothers and sisters, grandparents, aunts and uncles and any other people who are special to the bride.

■ Bride with Her Family

With the whole group posed, eliminate the groom. Now, shoot the bride alone with her whole family. The next step is to begin eliminating groups of people as you added them in the previous section. Remove the aunts and uncles, grandparents, then brothers and sisters (photographing each new grouping) until you have the bride alone with her parents. After a few shots of the bride with Mom and Dad, move on to shooting the bride alone.

■ The Bride

Start by shooting full length portraits of the bride, including profiles. Then go on to do as many variations with the bride alone as you can.

■ Couple with the Groom's Family

Now, it's time to bring back the groom and pose the couple together with the the groom's family. As with the bride's family, begin by adding the parents, then the brothers and sisters, then the grandparents, then the aunts and uncles and anyone else special to the groom.

■ Groom with His Family

Now, eliminate the bride and shoot the groom with his family. As before, begin eliminating groups of family members until you have the groom alone.

■ The Groom

I like to take the groom away to different areas of the church for his portraits, often shooting with a wide-angle lens. A stained glass window or a pew (as you see in the groom's portrait on page 75) can provide an excellent backdrop. The groom's attire is generally not as distinctive (or symbolic) as the bride's, so adding environmental elements can enhance and strengthen the image. Pay special attention to the hand posing for grooms.

■ Bridal Party Set-Ups

Start with the bride and groom with the best man and maid of honor. Next, begin to work with the whole group, shooting the bride and groom in the center. For one shot, pose the groomsmen on the groom's side, and the bridesmaids on the bride's side. Next, pair up couples of attendants and arrange them evenly on each side of the newlyweds. Finish by shooting the groom with his groomsmen, and the bride with her bridesmaids.

■ Exit Shots

A shot of the couple leaving the building is an important one to get. Try to do a few "fun" shots coming out of the church; just give the couple directions and let them have fun. Another nice shot I like to get is of the bride and groom at the limousine. I follow it up with a shot of the newlyweds inside the limousine.

Again, the specifics of all of these phases will be covered in further detail throughout the book, but this outline should provide you with a good framework for organizing your time with the couple at the church.

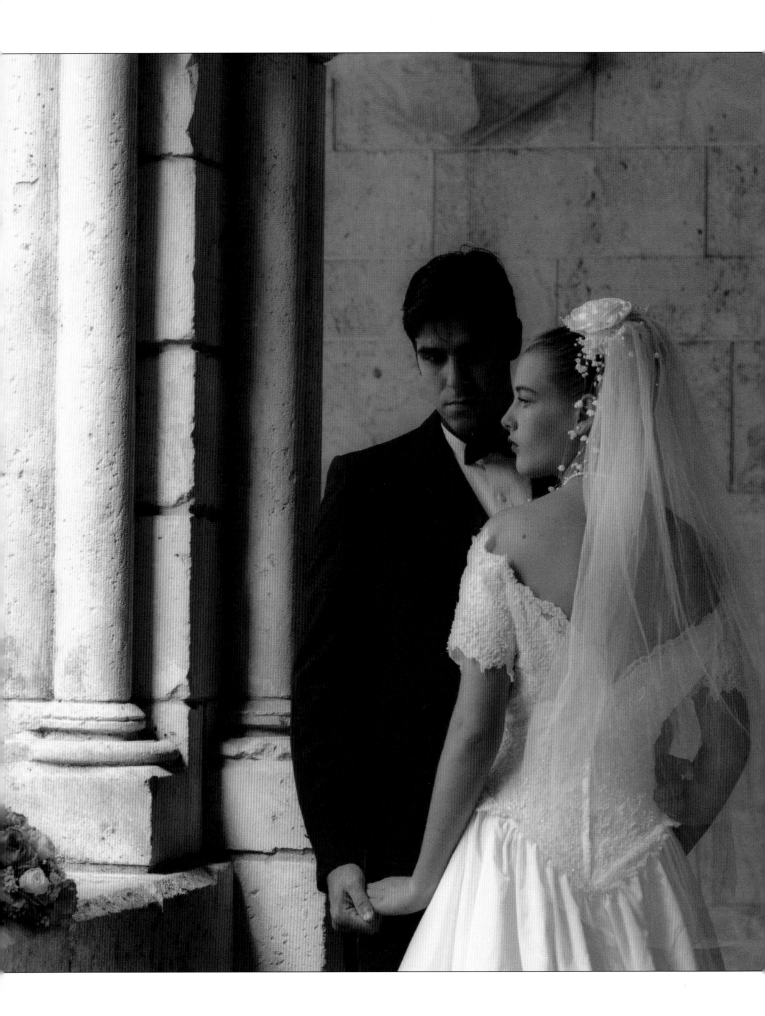

THE BRIDE AND GROOM

Creative

Lighting

and

Posing

For

Wedding

Day

Portraits

■ **Unique Beauty**

Every wedding is very unique. Every wedding you shoot will have different stages, and you'll find that there will always be something to do, something to plan, something to execute with your camera. Clients who book our expertise in posing and lighting know ahead of time that these images take a little bit more time to shoot. Yet, with careful planning on our part, we can work efficiently and still produce truly unique and beautiful images.

■ **An Elegant Pose**

An image like this is included in our photography of almost every wedding we shoot. Essentially, the shot uses the groom as a prop and lets the emotions of the bride make a simple but meaningful statement about the couple's wedding day. Remember, what's important about the day is the emotions of the event. You don't always have to include flowers or a full shot of the dress, or even big smiles to show this. As in this image, sometimes you may want to portray the more subtle, intimate aspects of the day.

■ **Setting up the Shot**

This is a simple pose to execute. Just bring the groom up close to the bride and have him wrap his arms around her. Next, position the bride in complete profile and sweep the veil back from her face. She should be posed facing the main light source. With the groom in place, have him turn his face toward the light but continue to direct his eyes at the bride.

■ **Feelings**

Again, an image like this is all about emotion. When you're working with subjects on a photo which you want to reflect their feelings on this day, you need to cultivate the mood you're looking for. Talk in a soft voice. Ask the couple to think about the day they first met, or about what this day means to them. This is such an emotional event for the bride and groom, you may even see a tear or two. What could be better than immortalizing on film such profound human emotions? It's one of the things that makes me feel proud and lucky to be a photographer.

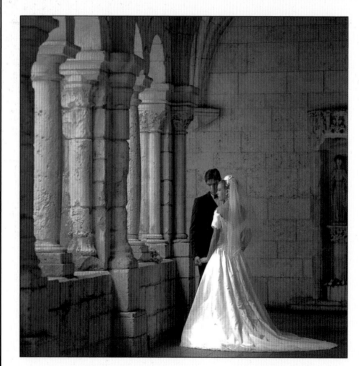

— Hints and Tips —

When shooting wedding portraits keep a careful eye on what is happening in the periphery of the shot, as well as what's going on in the background. Any number of distractions can become a problem, from stray people, to coats left laying on pews, to cars passing an environmental shoot. You need to develop a sixth sense and work to catch distractions before they happen.

Beautiful images don't have to be difficult to light or pose. For the shot above, the exquisite indirect light provided by the overhang in this location really makes the image. I simply posed the groom in a ²/₃ view, with the bride facing him in profile. I placed the couple in one third of the frame, snapped a Polaroid, then shot the final image.

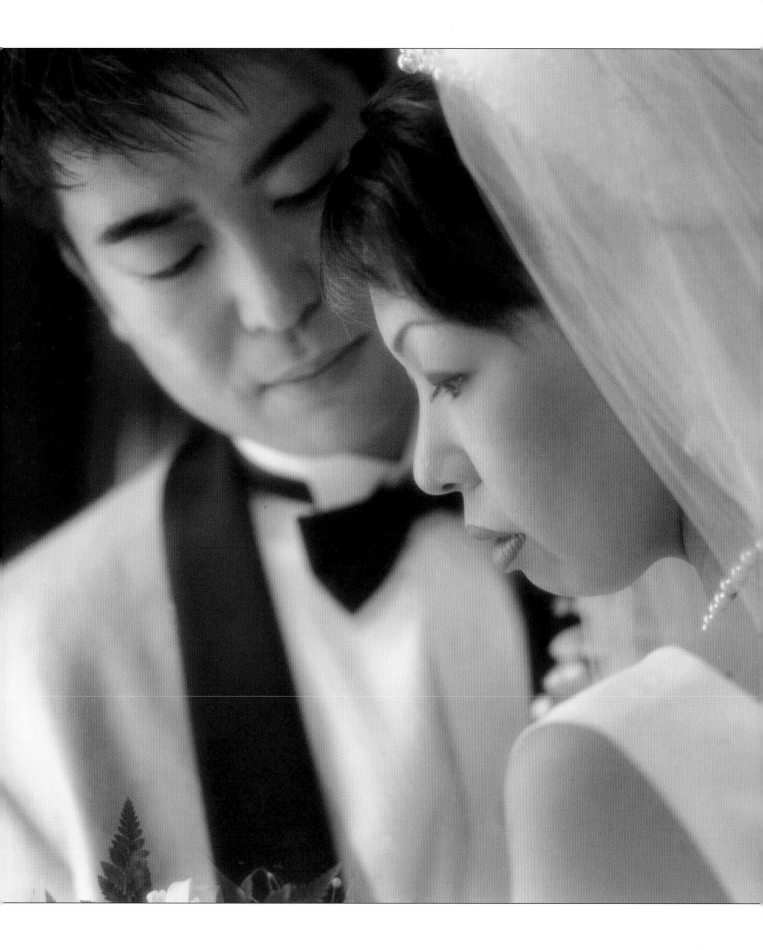

Qualifying the Client

A wedding photographer's net cost has many components to consider. Thus, it is important that you put some thought into your pricing and have a definite plan down on paper.

I am strongly against quoting prices over the phone and urge you to avoid this. Clients who demand a price over the phone are shopping for price alone, not for the quality work that you can provide. Instead, tell the client that you would be happy to provide them with a price list and suggest that they stop by or make an appointment to see your work. This is called "qualifying" your client.

Lighting

This is normally a very well lit room. There is light from the windows behind the couple, as well as from overhead light fixtures on the ceiling. The light overhead gave me an instant hair light for this shot, adding sparkle and highlight to the couple's hair. I metered for the overhead light, then used a Quantum bare bulb flash on a radio slave to the right of the couple and placed very high. This bare bulb combines with the ambient light to produce very nice highlights.

Equipment

I shot this image using an 80mm lens on my Hasselblad and with ASA 400 PMC Kodak film.

Posing

This is a traditional pose for the bride and groom and one I try to shoot at every wedding. It's fairly simple. First, place the bride. She should stand with her weight on her back foot, with one shoulder slightly lower than the other. Her face is then turned toward the higher shoulder. The groom is then brought in behind the bride. Notice how the groom's body is half covered by the bride's. This makes the pose flattering even for a heavy groom.

Left: *Ambient light was combined with bare bulb flash for this portrait. It's a simple but efficient lighting set-up that provides consistently good results.*

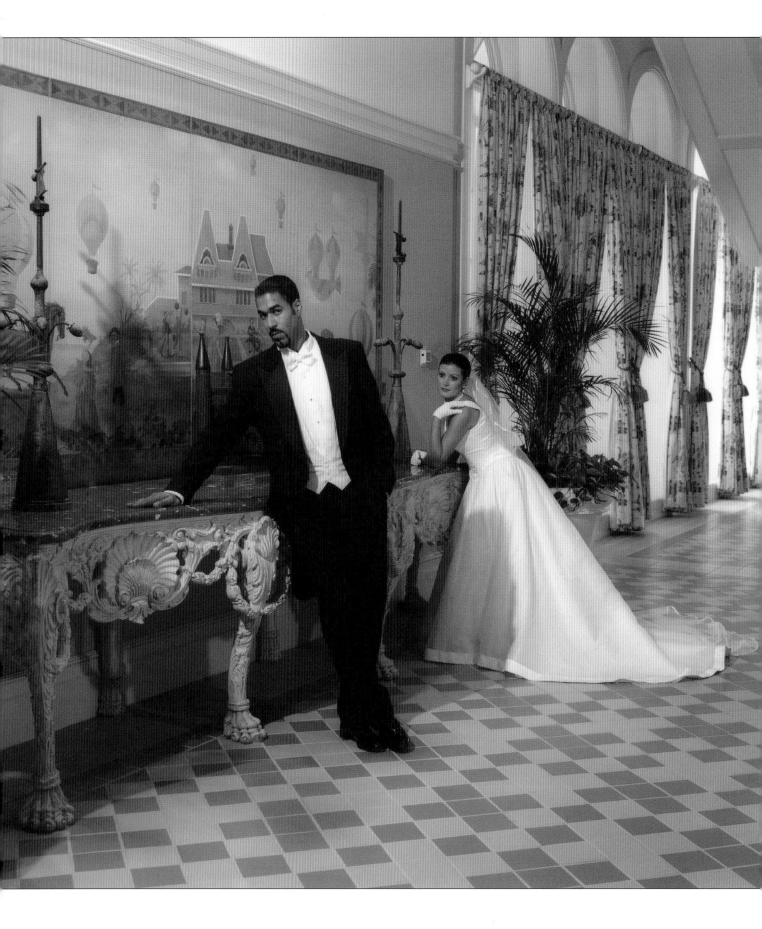

Formals

Formals are the part of the wedding photography for which you need to reserve the most time. They are also images for which you need to keep a particularly careful eye on the design, perspective, and details. Examine the lines of your subjects and the background. I like fluid lines and tend to look for S-curves. I also like images with perspective, so I am very fond of including architecture in my wedding formals (for more on this, see page 69).

Details

I also urge you to take the time you need to pay close attention to the details. Little things like a not-so-perfect veil, a crooked tie, or the stems showing on the bouquet can ruin an otherwise beautiful portrait. They may not seem like much, but the details can make or break your image.

Posing

I like to put a little "dance" in my poses – a sense of swing or movement that makes the photograph a more natural and vivid portrait. After all, if you are looking for elegance in your images, why would you want poses that just make your ·subjects look stiff? Be confident when instructing couples on poses you are looking for. Your confidence will assure them that they are in good hands, and will encourage them to put their trust in you.

Albums

Once you have a good selection of sample images to show your prospective clients, you should invest in some sample wedding albums. Don't just go for the most expensive ones in hopes of impressing your high-end clients. Rather, put together a range of albums, from finer quality to lower end. This ensures you will have an accurate sample to show clients with various budgets.

Left: This image (of a different couple in a similar pose at the same location) shows how bare bulb flash was combined with available light. The bride and groom were posed with a sense of dance and movement that makes for a strong composition.

Posing

Three portraits are provided here with very similar posing. The couple below was posed for the full length shot (right), then we moved in for a tighter image (left) – two nice variations from one basic pose..

Lighting

If you look closely at the lighting patterns on the faces of the subjects, you'll see that they are practically identical to those in the portrait of another couple featured on page 33. The bride was posed in profile facing the main light source. The groom was then brought close to the bride with his arms around her. In the portrait on the right, the light hits the groom's face at about a 90° angle, creating a soft, split-light effect (half of the subject's face in light, half in shadow). In the portrait on the left, the groom's face was turned more toward the light, although he is still looking at the bride. This turn of his head allows more light to fall on his face, creating a Rembrandt lighting pattern. This pattern results from light falling on the subject's face at about a 45° angle, and creates a pattern of light and shadow that is good for showing the shape of the subject's face.

Styling the Dress and Veil

The dress and veil are important and symbolic parts of the wedding day. You should take care to treat each gently and style them with care for every image. The basic principle for styling the gown is to make sure that it falls in smooth, natural curves and is never allowed to become bunched. For the veil, you should also make sure it falls smoothly and naturally without hitting any obstructions. You should also try to arrange it so it falls as straight as possible.

The full length portrait on the opposite page incorporates the beautiful architecture of this arch in the bridal portrait. Notice how the bride's fluidly curved pose compliments the other curved lines in the composition, and how her dress falls smoothly and naturally.

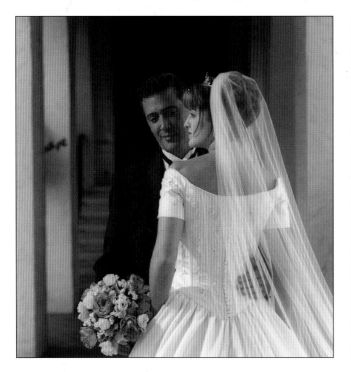

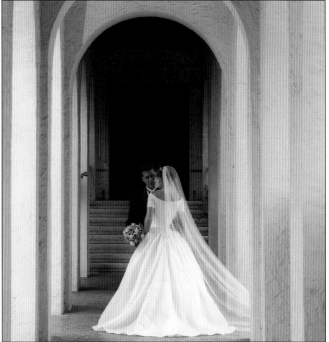

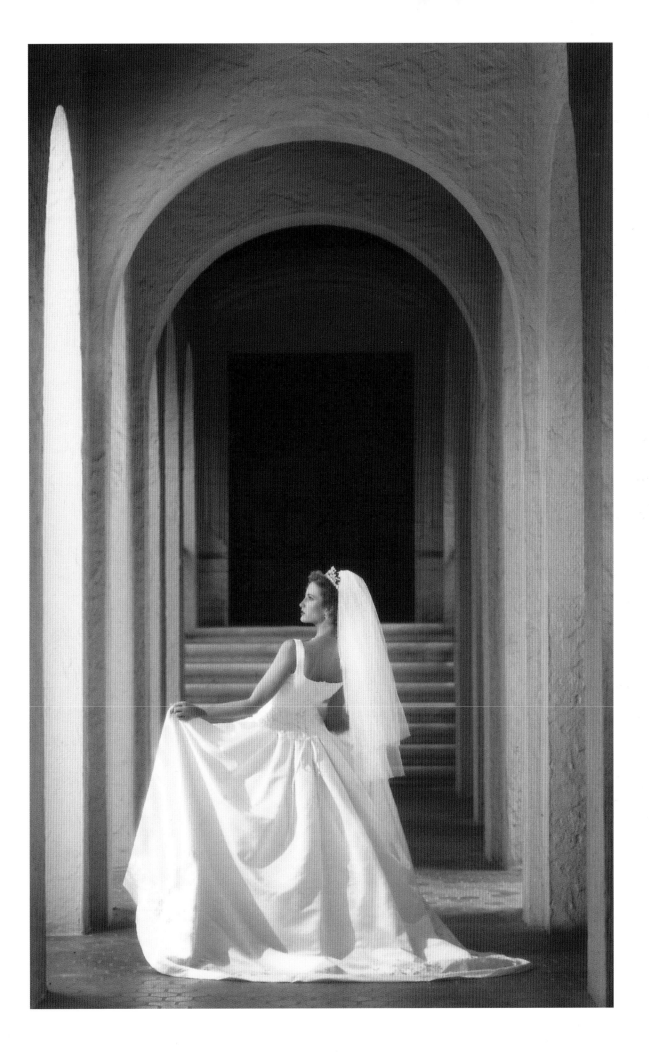

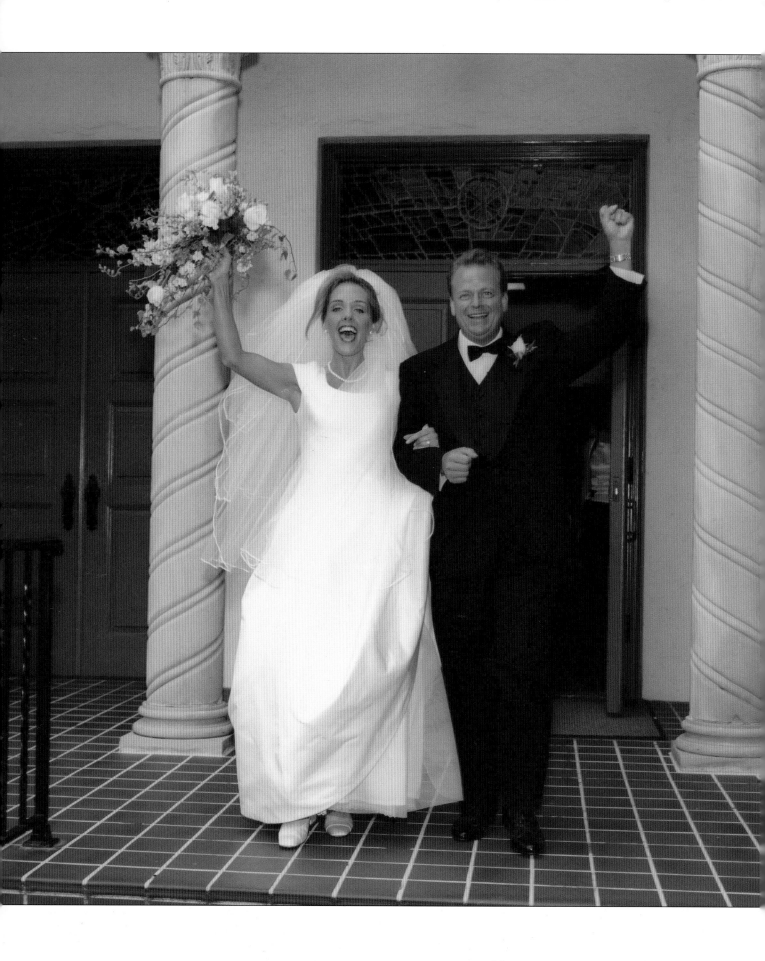

■ Leaving the Church

When I'm finishing up formals inside the church, I know that the guests and family of the bride and groom are outside, just waiting for the newlyweds to emerge from the church. Whether the guests will be throwing rice or blowing bubbles, why not get them in on things and take some fun shots of the newlyweds?

This is a great traditional moment, but an event you should take control of to get the best images. The first thing I do is get the parents, immediate family and bridal party placed as closely as possible to the door. They will be the most enthusiastic members of the crowd, and I want their energy and emotion to surround the couple and spill over into the images. Once everything is set, I tell everyone to have fun, and start shooting!

■ Other Shots Outside the Church

Once you've captured a few great shots of the couple leaving the church, there are some other moments you'll want to cover during the couple's departure. First, I like to get a shot of the couple getting into the limousine. Follow up the image with a photograph of the newlyweds inside the limo and ready to go. If they've decorated the car (as below), you should also get a shot of the vehicle.

◾ A Good Assistant

I have always trained my assistants to someday become wedding photographers themselves. There are a few basic skills for wedding photography that you should make sure to teach your assistants from the start. They should learn how to meter, how to load and unload film, and how to style the bride's dress and veil. They should also be able to hold a second light and, most importantly, keep an eye on the lights. You should also let your assistant look through the lens and shoot some easy shots to build his confidence and ability. Finally, an important duty of an assistant is to make sure that all of the film and equipment is accounted for throughout the day.

◾ Communication

As you work with an assistant, you should almost develop a secret language of key words and hand signals that will allow you to communicate efficiently and without disturbing your clients. For instance, if I think a light is malfunctioning, I will give my assistant a particular expression. He may then reply "Ambient light." This lets me know that the exposure was correct, but the flash did not fire.

If this happens, I simply go to the bride and spend a few minutes styling her dress or fine tuning posing while my assistant fixes whatever was wrong with the light. Then we can continue.

◾ Posing

This elegant ¾ length portrait features both the bride and groom in profile, with the main light source emanating from behind the groom. Notice the nice curve provided by having the bride bend back slightly. Having the couple look into each other's eyes adds a bit of romance to the image. Also note the beautiful architecture in the background, which gives the portrait a classic look.

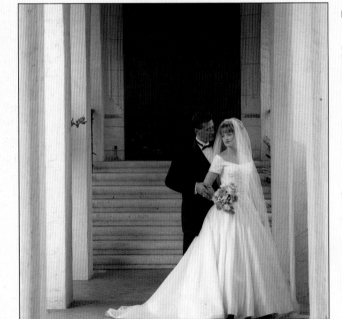

— Hints and Tips —

Sometimes you may come across a bride or groom that does not have particularly attractive hands. Since many wedding images feature the hands (and especially the rings), you need to have a strategy for dealing with this. The secret is coverage – use the bouquet, or gloves or even a hat. For ring shots of the couple, use the most attractive hand over the less attractive hand.

Careful composition is the key to this image. Try to imagine the couple posed dead center in the frame – it would simply not be as interesting an image to look at. The lighting was simple, with the bride turned to face the light and the groom behind her. The placement of the groom's hand on the bride's arm lends the image a sense of warmth and intimacy.

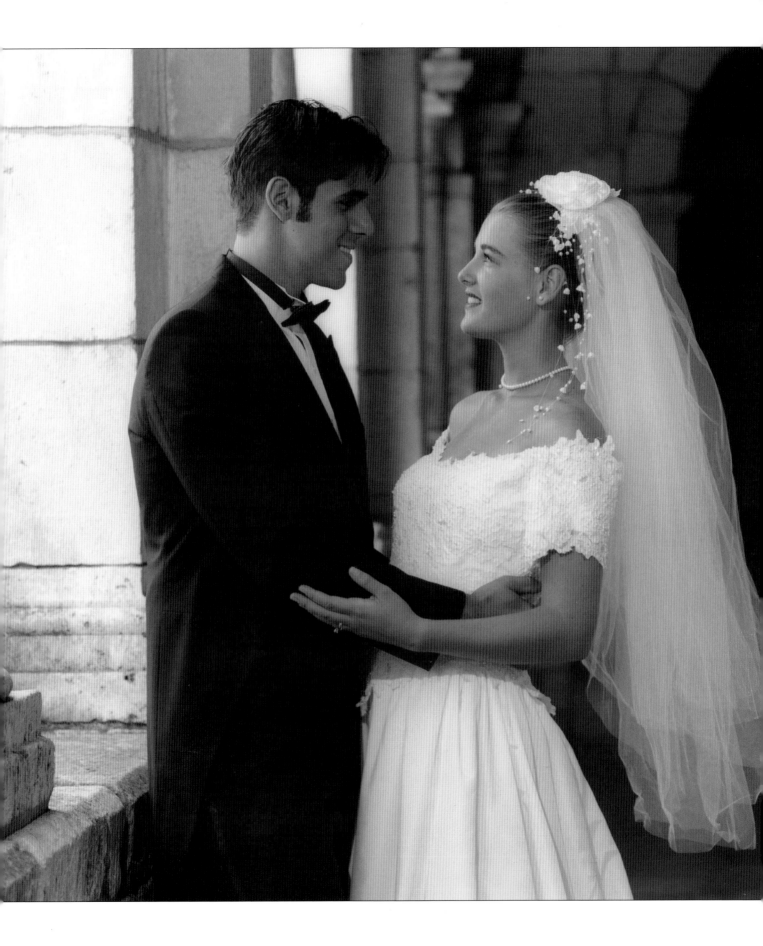

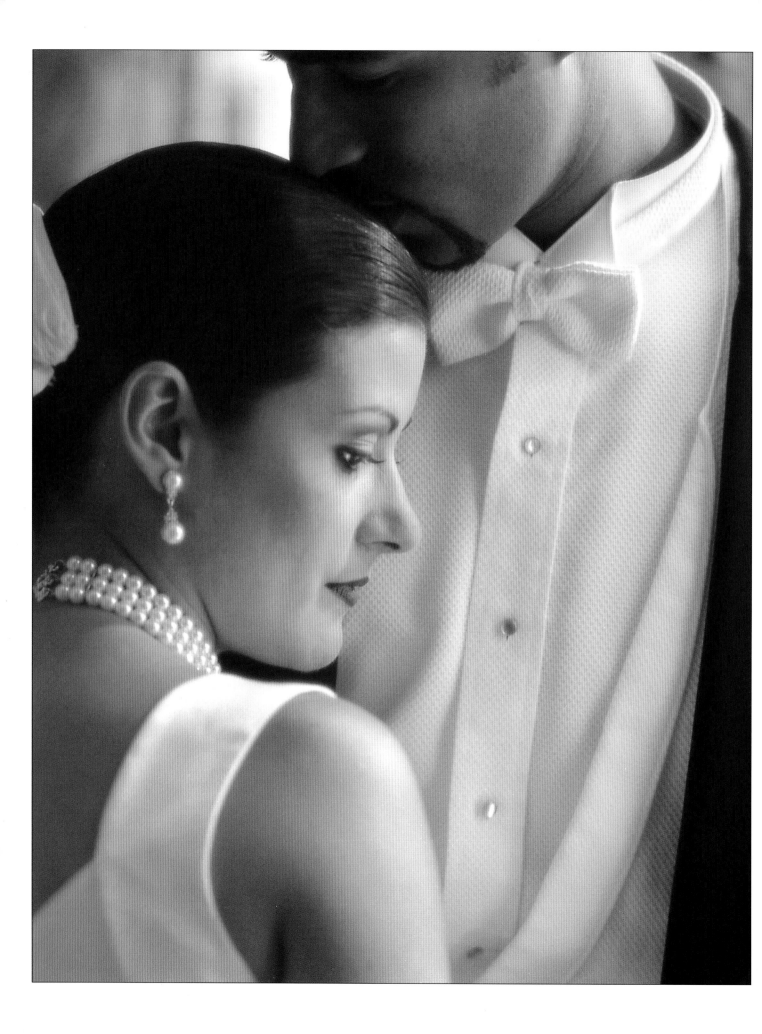

■ Polaroids

Formals require close attention and can be time intensive. Although they take a little more time, shooting test Polaroids can be useful during wedding photography because they allow you to accurately evaluate the light and pose for a shot. If you do take a test image this way, consider giving it to the couple. They'll be happy with the instant memento and will have a nice conversation piece to take to the reception.

■ A Wedding Disaster

The worst experience I had shooting a wedding occurred when, apparently, the bride didn't tell the groom who would be performing the ceremony. When the Catholic groom came down the aisle and found a Rabbi at the altar – well, you can't even begin to imagine his expression. I could hear his parents saying, "Didn't you know what kind of ceremony it was going to be?" He was clearly very upset, but when it was time for the bride to come down the aisle, everything seemed to be settling down. The couple was pronounced man and wife, and after a hesitant kiss on the part of the groom, turned to face the guests and myself, and make their way down the aisle. As they made their way to the back of the church, I heard words flying that were much too harsh for this book. Things didn't seem to be going well, but I went ahead as planned and shot the rest of my images at the church. To make a long story short, when it was time for the cake cutting I was in position to shoot as the groom fed the bride. I guess it was time for the groom's retribution, because he picked up the whole wedding cake and dumped it on the bride! They never came back to the studio to pick up their proofs. Do you think this wedding will last?

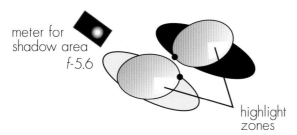

meter for shadow area f-5.6

highlight zones

bare bulb flash set at f-5.6

Hasselblad camera
180 mm lens
exposure: f-5.6 at 1/30 second

■ The Veil as A Prop

These high-impact images happened as the result of a windy day, but could be duplicated in any weather. The veil is used as a prop, surrounding the closely-posed couple as a symbol of their wedding day. The veil has other great applications as a prop; to read more about these, turn to page 12.

■ Photojournalism

Photojournalistic coverage means simply covering the wedding with highly artistic, and basically unposed, candid images. Most of my clients still prefer very traditional wedding photography, but photojournalistic coverage of weddings is becoming increasingly popular in the industry. I try to do a little bit of this at every wedding. As you can see in images like this, or the exit shot on page 40, these images can be totally natural, spontaneous and appealing.

Keep your eyes open for opportunities to capture some of these priceless images at every wedding.

■ Composition

Basically, the photographs below and on the opposite page are based on a bullseye composition – perfectly centered in the frame. Although I don't generally center my subjects (as you can see throughout this book), it can be an effective look for the right subject.

■ Tilt

With the couple centered in the frame, I simply tilted the camera to add another visual element to the composition. The strongly centered images paired with this tilted element have strong impact and a dramatic feel. The tilt can also be achieved later by having the lab turn the negative in the enlarger.

Opposite and Left: Two creative and fun shots using the veil as a prop. A tilt of the camera makes the composition of these shots especially interesting.

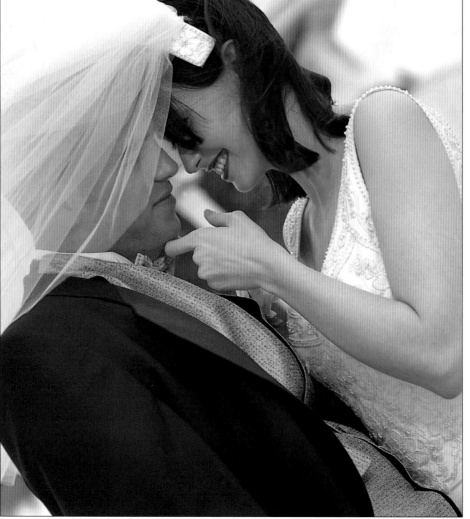

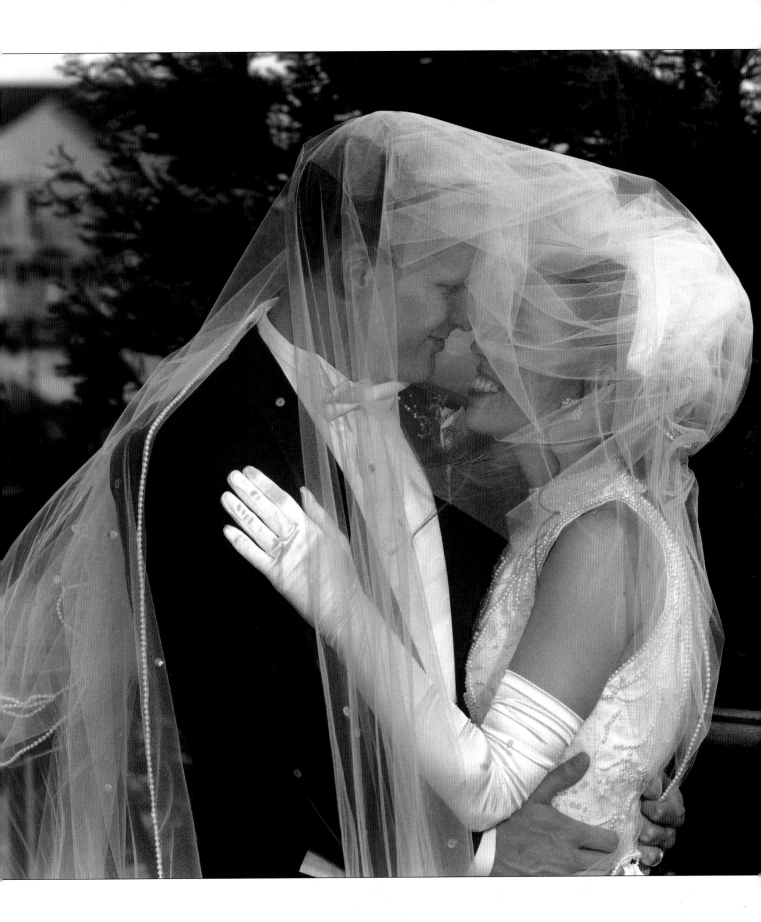

■ Location

This is one of the largest churches in Hawaii, and we shoot weddings here almost every day. With repeated shooting at a site, you have an opportunity to get really comfortable with the light and setting, and to build a repertoire of shots that you know will work perfectly. This is one of those. It's an image we do for just about every wedding in this church.

■ Composition

You should always look carefully at the lines of your subject. Here, the composition begins with the diamond shapes and rectangles of the church's architecture. The subjects were then posed with an eye to curves. This creates a contrast between the massive architecture and the subjects, which are comparatively small within the frame.

The beautiful lines of the architecture draw your eye through the image, but the curves of the couple's posing create a contrast that keeps them from being overwhelmed by the architecture.

■ Hand Posing

The posing of the couple is made more polished by the careful attention paid to their hands. The groom leans back on a pew with one leg crossed over the other. It's a relaxed pose that looks natural. His hands are placed casually – one at the pocket of his trousers, one on the pew in front of him. The bride holds her bouquet gracefully, with one hand draped lightly on the pew in front of her. The scene was fine-tuned from the balcony, where I shot it. I firmly believe in evaluating a scene through your lens before considering it set.

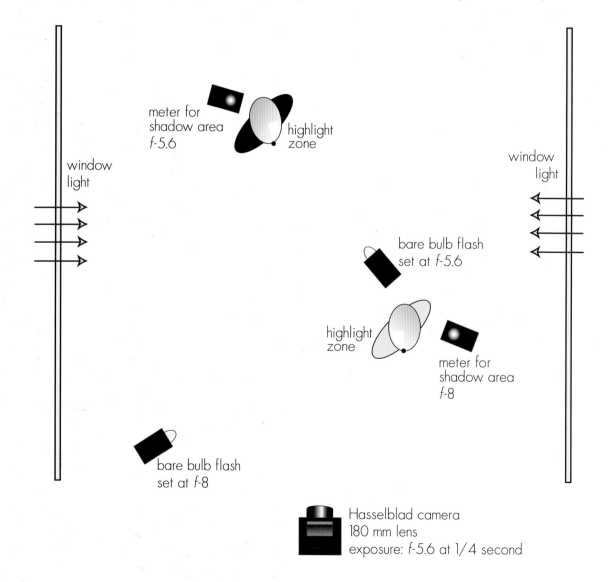

window light

meter for shadow area f-5.6

highlight zone

bare bulb flash set at f-5.6

window light

highlight zone

meter for shadow area f-8

bare bulb flash set at f-8

Hasselblad camera
180 mm lens
exposure: f-5.6 at 1/4 second

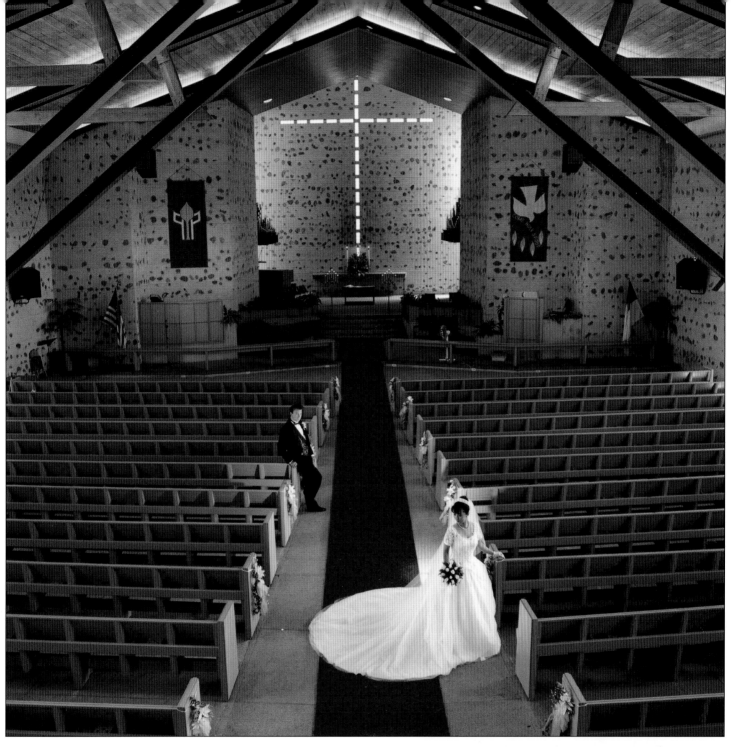

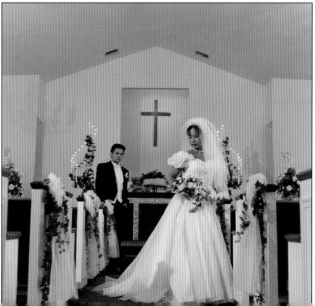

■ Polaroids

To help couples decide on whether they want environmental portraits and where they'd like them taken, I display a sample of Polaroids from various appropriate locations. The images show the sites at various times of day (especially important for nighttime existing light shots), and also include information like the type of film used and exposure information. Whenever discussing environmental portraits, it is important to stress to your clients that these images do take some extra time to set up and shoot.

■ Bad Weather

In case inclement weather should make your chosen location inaccessible, you should also make a point of discussing alternate plans with the bride and groom. Explain to them before the wedding that you can't perform miracles where the weather is concerned, but in the event of problems, you will take them to a particular alternate location and do some other poses. Let them know you have a solid contingency plan and that they will still get great images.

■ A Favorite Location

As you shoot more and more weddings, you will develop favorite locations that you know will reliably produce stunning images. This is one of my favorite spots for environmental wedding portraiture in Orlando, FL. It has everything you could ask for in a site — beautiful light, and a wonderful sense of perspective.

■ Posing

This is an image with attitude! I especially like the way the bride is holding her bouquet. Notice how the curve of her arm creates a dramatic line and adds a sense of movement to the couple's pose.

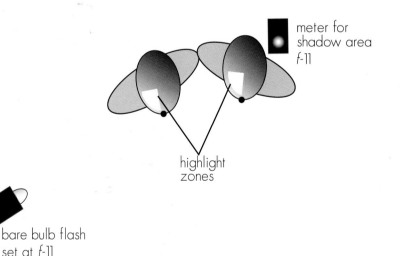

meter for
shadow area
f-11

highlight
zones

bare bulb flash
set at f-11

Hasselblad camera
180 mm lens
exposure: f-11 at 1/500 second

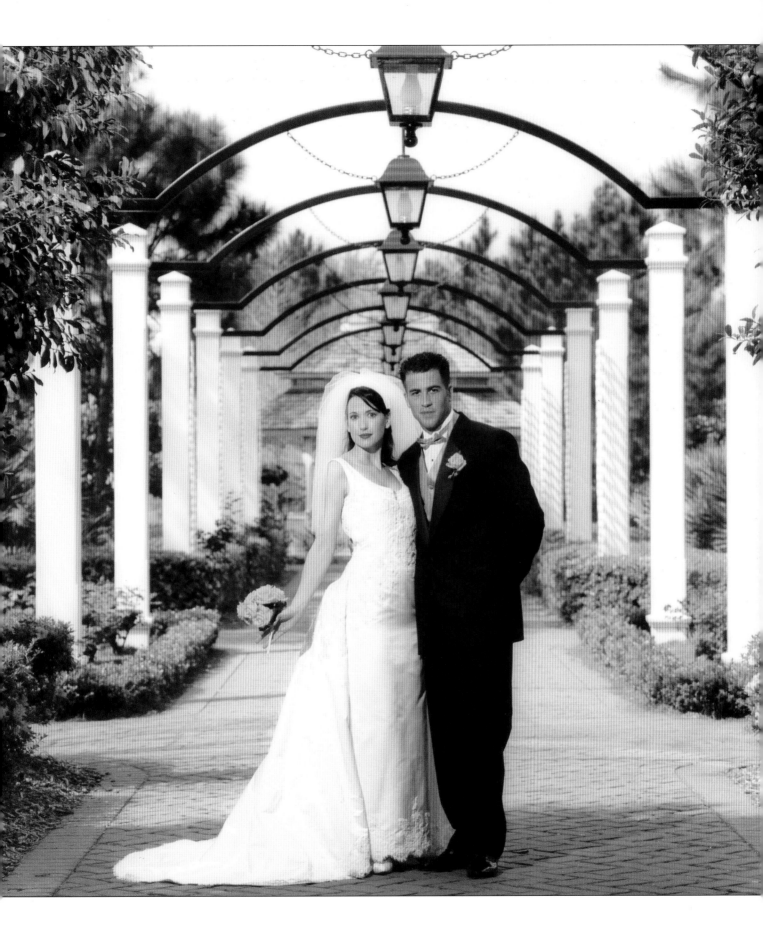

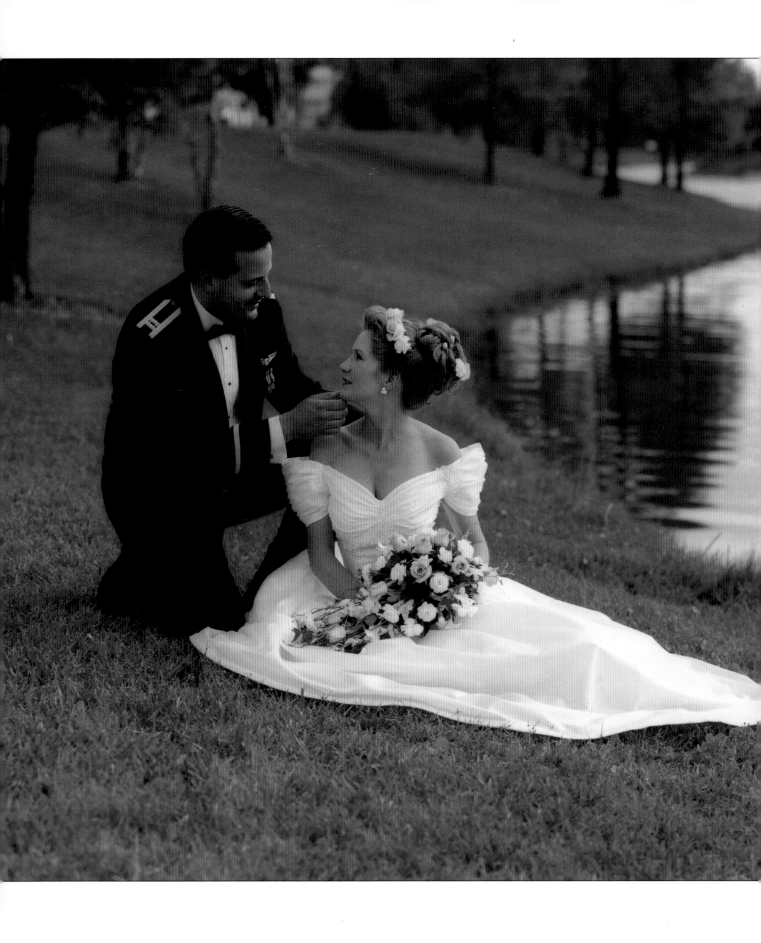

Flowers

The bouquet is a special and meaningful part of the bride's wedding day attire. It is also an important prop for your photography. When you use it in an image, treat the arrangement delicately and with care. You may wish to shoot it in many different areas – in the bride's hands, cradled in her arms, sitting on a nearby ledge, etc. Wherever you place it, be careful to conceal the stem area underneath. This ugly part of the bouquet can easily ruin an otherwise perfect image. When you photograph the bride holding her bouquet, instruct her to hold it gracefully and naturally, as does the bride on the opposite page

Timing

The usefulness of a particular location can change throughout the day, and from season to season. In Florida, where I live, there aren't too many seasonal changes to worry about aside from rain. In other climates, the changes can obviously be quite profound and are some-
thing to take into consideration when planning environmental portraits. You should also consider the time of day and think about the kind of light you will be working with. The traditional "golden hours" of early morning and late afternoon provide the most desirable lighting conditions, but be prepared to shoot throughout the day, and have strategies in place for working with natural light.

Composition

The angle from which I shot this image was extremely important, since I wanted to capture the couple in perfect profile. Styling the dress was also a crucial element, and was handled by my assistant. All of this preparation contributed to the strong composition of the image. My favorite element is the way the gown's train echoes the S-curves of the stream behind her. Like the stream, her dress was also framed to lead your eye out of the photo. This creates a dynamic composition which invites the eye to linger and move over the photograph.

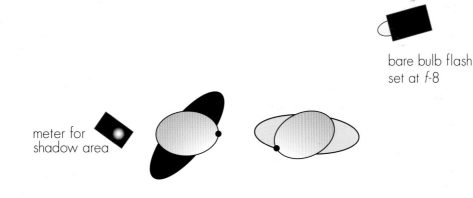

bare bulb flash
set at f-8

meter for
shadow area

Hasselblad camera
180 mm lens
exposure: f-8 at 1/125 second

■ Black and White

Although color is still the primary choice of most brides and grooms, black and white images are becoming more and more popular. This rebirth has been driven, in part, by the popularity of the photojournalistic style of wedding photography and the renewed popularity of black and white images in the media. Black and white photography is a unique art form with a classic and artistic look that is appealing to many clients.

■ Handcoloring

In addition to their "normal" presentation, black and white images can also be printed on colored paper, or hand-tinted to create highly appealing products to supplement the color photography in a couple's wedding album. Very artistic handcoloring can create a beautiful and truly unique piece of art for the bride and groom.

■ Toning

An especially popular type of image is the sepia toned black and white. With a very traditional and refined appearance, these images sell well as a supplement to color photographs. I would highly recommend having some samples available to show your clients.

■ The Bottom Line

Although it is becoming popular, it may not be worth your time to pack and shoot black and white in addition to color. If clients want black and white images, consider having them printed from the color negatives. This is not cheap (we charge about 50% more since the prints are all done by hand), but it can be an efficient means of offering the option of black and white to your clients.

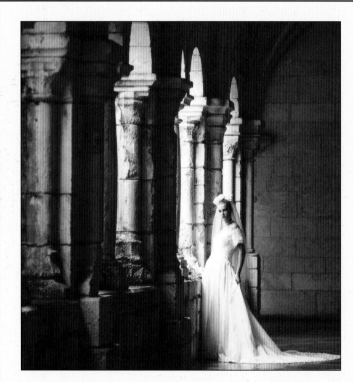

— Hints and Tips —

Keep an eye on those flowers! Sometimes you may need to add them to a shot, other times you'll want to remove them to achieve a different look. Whenever they are in frame, make sure the flowers are held naturally (and in the case of party shots, in the same way by all the bridesmaids). Pay special attention to the stem area; this isn't the prettiest part of the bouquet and should be concealed somehow (by the bride's hand, her gown, etc.). Having a stem showing or a bouquet awkwardly held can spoil an otherwise great shot.

Indirect light from an overhang is the key to this elegant image. Instead of using the flowers in the bride's hands, I used them as a prop. This placement of the flowers left the bride's hands and arms free for more dramatic posing. Here, her body is bent back slightly and her arm bent to create a pleasing S-curve.

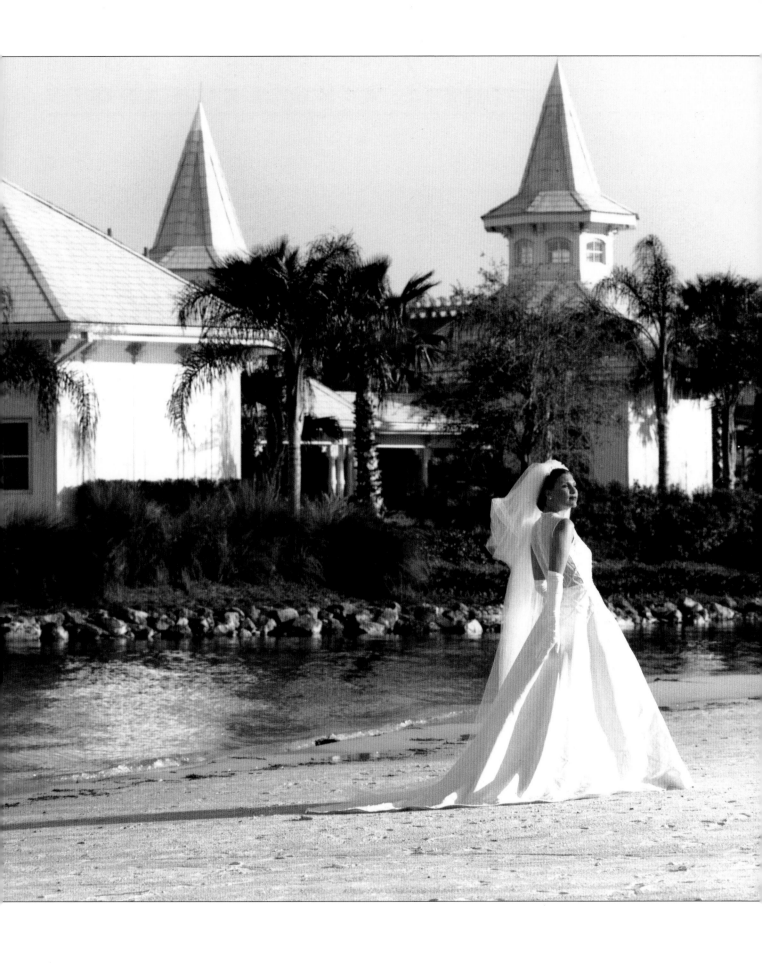

■ Three Ring Exchanges

The ring exchange is one of the most important symbolic parts of the entire wedding ceremony and, without it, the matrimony would not be complete. As such, it's something I want to make sure to capture fully. I start by photographing the actual ring exchange during the ceremony, then go on to shoot the exchange two more times.

The second ring exchange shot occurs on the return to the altar after the ceremony. Here, I re-create several important stages from the ceremony, but shoot them from the angles and with the lighting equipment that was too disruptive to use during the real ceremony. See pages 26-29 for more information on this phase of the shoot.

I also like to go on to shoot a final series of ring exchanges outside while we are doing other environmental photography.

■ The Outdoor Exchange

Outdoor ring exchange shots are very popular among my clients, and something I recommend you consider offering to yours. I shoot them in full length, $^3/_4$ length and close up varieties. A close-up or enlargement, like those shown on the opposite page, will look especially nice in an oval mat.

To pose the couple, I start with the groom in profile and the bride in a $^2/_3$ pose looking down at her wrist. Ask the bride to bend her wrist slightly, or ask the groom to put a little pressure on it. This will give the bride's hand a very feminine look. I shoot the image with a telephoto lens to let the background go totally out of focus.

■ Additional Shots

Now that you have the bride and groom in this nice pose and lighting situation, try some variations — her profile to his $^2/_3$ pose, the same image in a $^3/_4$ length, and a full length, and the list goes on.

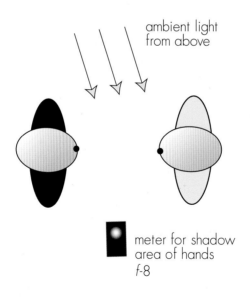

ambient light
from above

meter for shadow
area of hands
f-8

Hasselblad camera
180 mm lens
exposure: *f-8* at 1/60 second

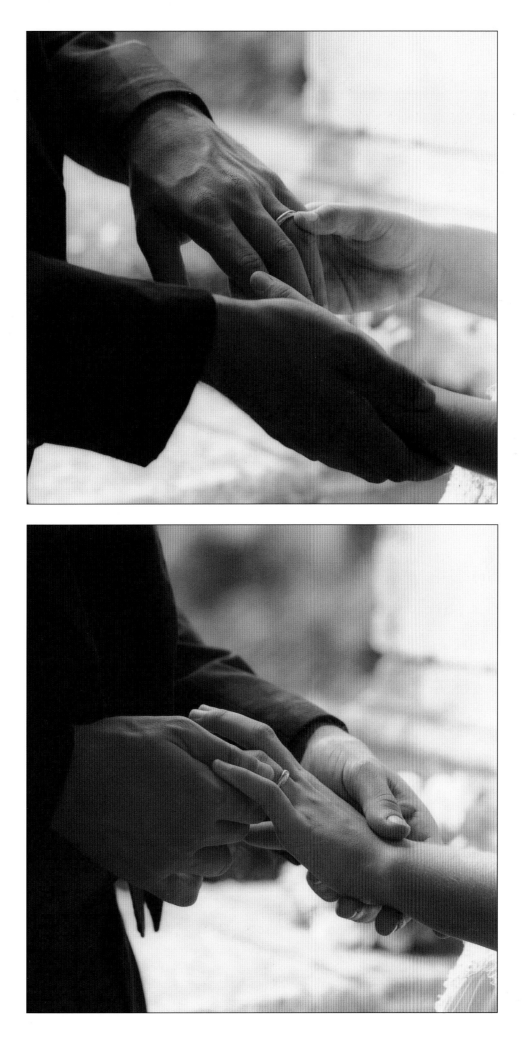

■ The First Time, Every Time

Although you may shoot dozens, or even hundreds, of weddings every year, you should remember that for your clients, their wedding is a totally unique event. While the newlyweds will value you for your experience, they will also appreciate your showing enthusiasm for their special day. Treat every couple with the same care, attention and concern that you gave your very first client.

■ Location

This image was shot at a monastery in Miami. This spot is a great location for wedding photography for several reasons. First, the beautiful masonry provides an elegant and classic background. Second, the overhang ensures great directional light regardless of the weather. Keep your eyes open for great, versatile locations like this.

■ Lighting

The indirect light at this spot is easy to place subjects in and can be supplemented, as here, with bare bulb flash if desired. After taking a reading on the subject's faces, I set the Quantum flash head appropriately and positioned it at a high angle to open up the shadow areas.

■ Posing

This should be a standard pose in your repertoire. Essentially, the groom is shot in profile over the bride's $2/3$ view. The bride's head is then tilted toward the groom's high shoulder. Both of the newlyweds display their rings, and the bride's wrist is bent to elongate the appearance of her fingers and create a very feminine look.

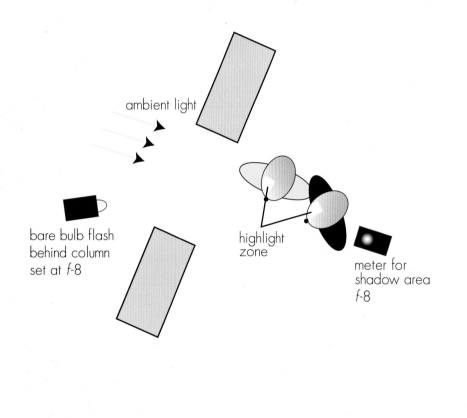

ambient light

bare bulb flash
behind column
set at f-8

highlight
zone

meter for
shadow area
f-8

Hasselblad camera
180 mm lens
exposure: f-8 at 1/60 second

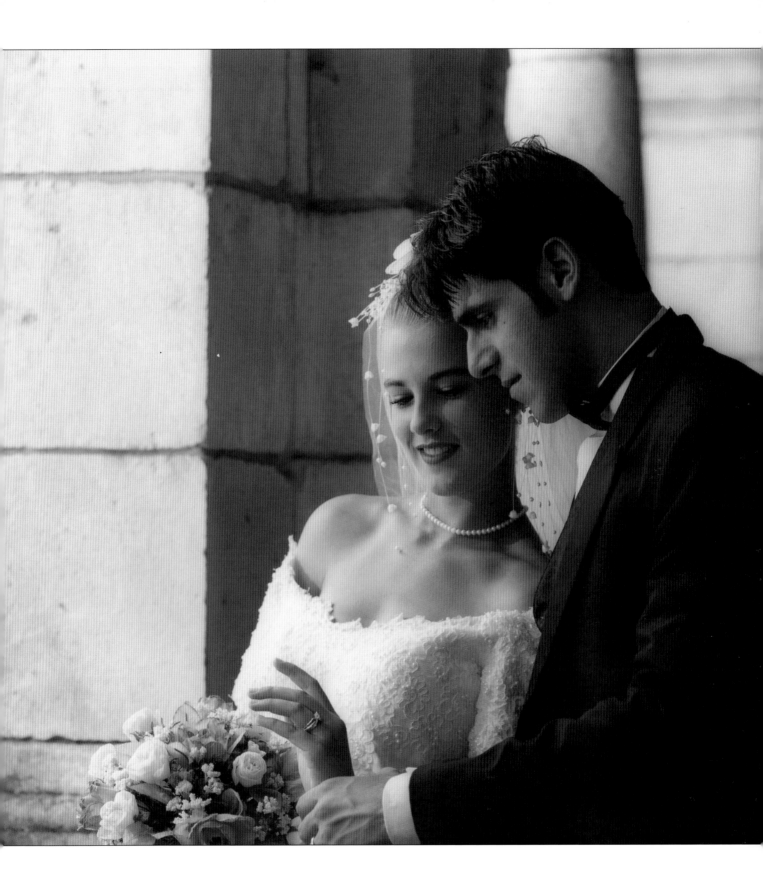

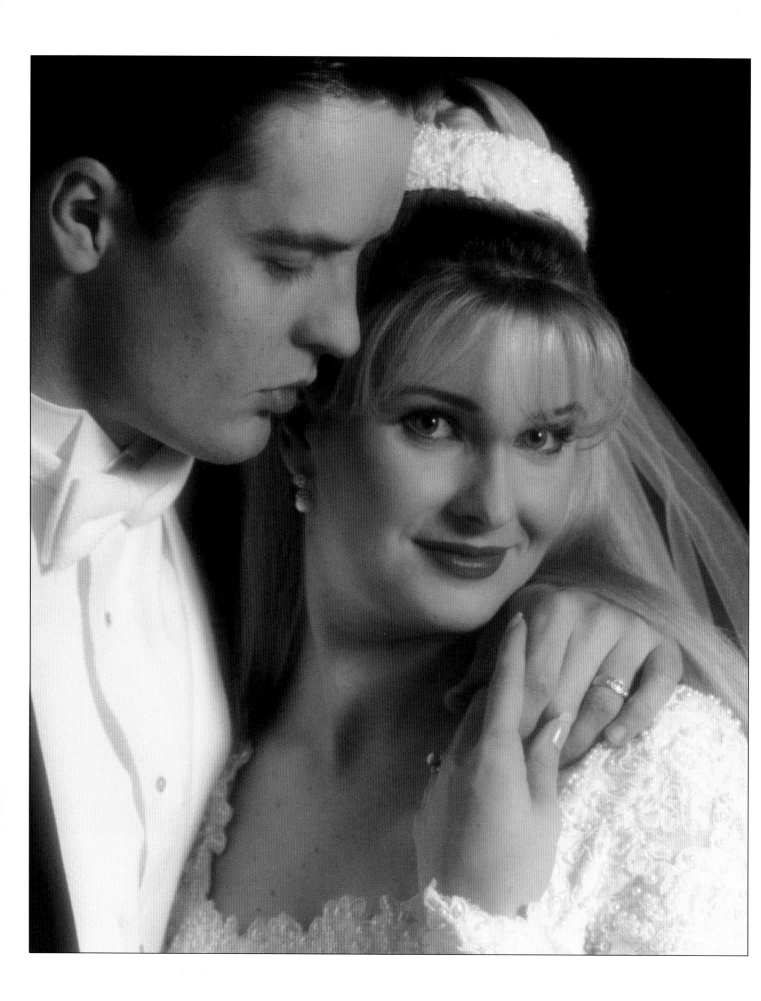

◼ Working with Grooms

Working with grooms is much different that working with brides. For one thing, grooms are generally likely to be less cooperative. Like the bride, the groom is facing many stresses on this important day. He is leaving behind single life, he's nervous, he feels the pressure of being in the spotlight, and to top it off, he may even have a hangover from celebrating with his friends the night before. Whatever the cause, if a groom seems excessively nervous, the first thing I do before shooting is try to get him comfortable. I'll take him on a little walk and get away from the groomsmen. I also try to engage him in a conversation about sports, business, travel – *anything* other than the event at hand.

◼ A Tough Shoot

I think that the weddings that have been the most difficult for me have been those when the groom and groomsmen show up drunk. The wedding may be thought of as the bride's day, but the groom is 50% of the event, and when he's not in good shape it can be difficult. In this situation, you still have to work with the guys. You know what you have to do, even if they don't want to pose at all. Somehow, some way, I have always managed to get them to cooperate, but it's a situation where you'll have to be creative and think on your feet. One good line of reasoning that seems to make an impact is to remind the groom that he has invested a lot of money in your work and you're sure he wants that to pay off with a great wedding album. You may also want to remind the guys that the sooner they let you get your job done, the sooner you will be able to send them on to the reception.

◼ This Pose

This is a low key photo for which both the bride and groom were posed sitting. The pose features the groom in profile with his lips to the bride's eye. The groom's arm is brought around the bride's shoulder and they lightly hold each other's hand, showing off their wedding rings. Notice that I cropped the groom's head to give a clear view of the bride. Adding soft focus completes the warm and intimate shot.

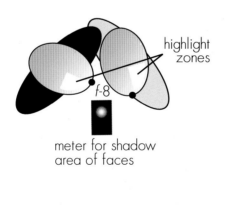

highlight zones

f-8

meter for shadow area of faces

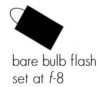

bare bulb flash set at *f-8*

Hasselblad camera
180 mm lens
exposure: *f-8* at 1/60 second

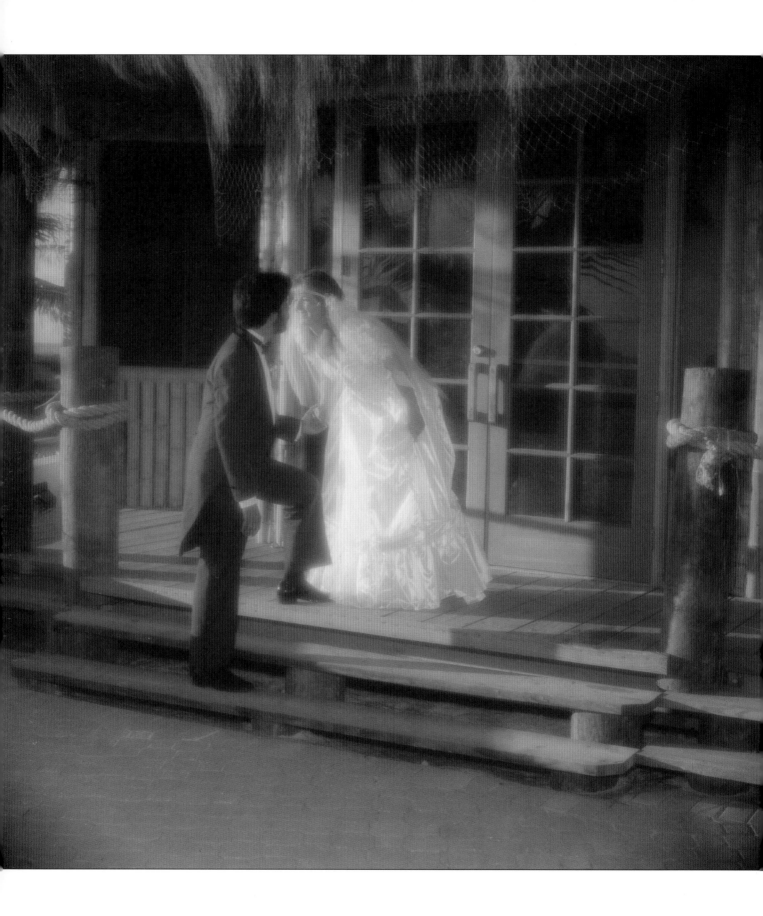

The Kiss

The couple kissing is an important part of the wedding tradition, and an important part of the imagery. But sometimes the couple just about to kiss can create an even stronger image. Here, the morning sun was too good to pass up, and the grass hanging down from the roof provided a great frame for the top of the photo. When I enter this photo in competition, I call it "Come to Me, My Love."

Bucking Tradition

This isn't a traditional image or a traditional pose, but then, it wasn't a traditional wedding either. Right after this shot, the couple took off their shoes and got hitched in an early morning ceremony on the beach.

Setting

This photo was shot in the early morning on a Ft. Lauderdale beach. The main light source was the sun, which shines in strongly from the left of the frame and adds beautiful specular highlights to the bride's face.

Polaroids

Polaroids can be a great tool when working on environmental photos. When I had learned the location of the wedding, I scheduled some time a few mornings before the day to go out and scout the location. Besides getting familiar with the features of the location, I shot some Polaroids so I could accurately evaluate the light and plan out the best locations for photographing the couple on the morning of their wedding.

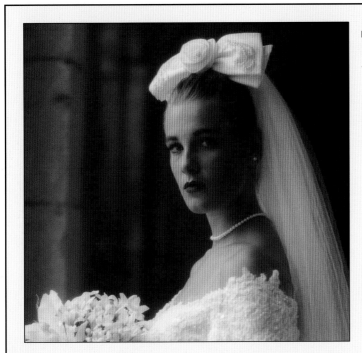

—Hints and Tips—

When working on environmental portraits with groups, I like to set up a portable flash system. Even though I have an assistant with me, ensuring seamless lighting can be tricky, and my assistant's efforts are better spent next to me than holding a flash. Remember to keep up the pace, as well – groups will get restless if you don't keep things moving along!

When working on location, time is especially valuable. This makes it especially important to know how to set up simple poses and lighting that will yield consistently beautiful results. Here, the bride was posed in a ²/₃ view. To achieve this, simply have the subject turn her face until her ear disappears. The flowers were lowered so that they formed an element of the image but did not overwhelm the subject's face. Once the bride was posed, I metered for the shadow side of her face, and allowed the indirect light through the arches to wrap around her face and veil. For a little variation, I shot from a slightly lowered camera angle.

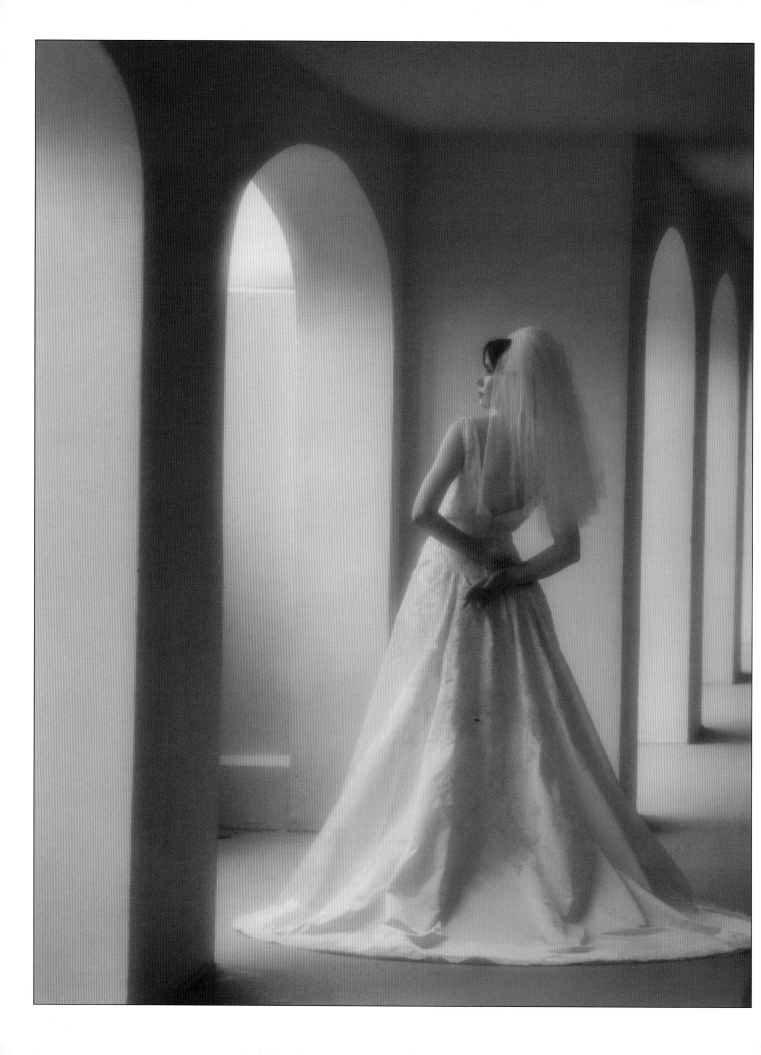

Awards

I'm very proud of this image, called "Delicate Curves" which was named a Professional Photographer's Association (PPA) Loan Print in 1998.

Posing

Putting dance into your posing is a great way to separate your work from the competition. The concept is one I learned from Stephen Rudd, an internationally known photographer, and is one that has really revolutionized and added life to my images.

Notice the graceful curves of the bride in this image. The pose was accomplished by having the bride put her weight on her back foot and bend slightly backwards. Her arms are posed gracefully behind her back and her wrist is bent slightly, creating a very feminine curve.

Location

Our office is located in the older part of Orlando, so there are many beautiful archways to shoot in. This one was selected because it was wide enough to accommodate the full skirt of her dress. In the original exposure, several arches were also visible to the left of the bride, but these were cropped out at my request by the lab. This leaves the bride in the left $^1/_3$ of the image.

Light

This is a perfect example of how beautiful overhang light can be. I metered for the shadow side of the subject, then set the bare bulb flash. This was positioned outside the columns and placed very high. It is a simple lighting set-up, but effective and elegant.

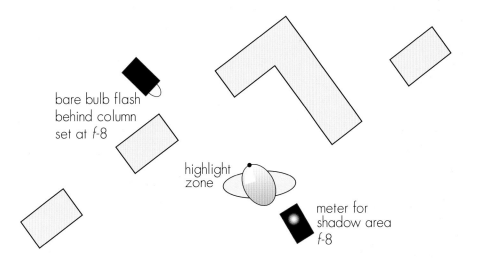

bare bulb flash behind column set at f-8

highlight zone

meter for shadow area f-8

Hasselblad camera
80 mm lens
exposure: f-8 at 1/60 second
Tiffen no. 2 soft focus filter

◼ Composition

The portraits you create are the way you make your statement as a photographer and an artist. Therefore, you should be conscious of the message you are creating every step of the way.

In this image, the natural and elegant composition make just the right statement about the bride. The veil was styled to fall neatly away from the face, creating a look that is soft but not fussy. The flowers are in frame but kept in the lower part of the photograph so that they do not overwhelm or interfere with our view of the bride's face. The bride herself was posed with her face at about a 45° from the main light. This creates the classic Rembrandt lighting pattern (indicated by the triangular pattern under her nose on the shadow side of her face).

◼ Camera Angle

Although it's barely noticeable, I have photographed many of these bridal portraits from an elevated camera position. All of the brides featured in this book are trim; nonetheless, shooting from slightly above eye level helps to eliminate any hint of double chin. For brides who are overweight, shoot from a slightly higher angle and have them look into the camera. Tilting the head up will make the skin look firmer.

Remember, it's your job as a wedding photographer to work with people's emotions on the biggest day of their lives – every wedding is a once in a lifetime event. Brides want portraits that show them at their absolute best and most beautiful. Do anything you can to show them in their best light.

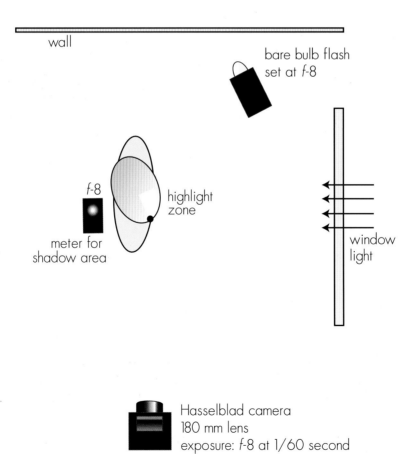

wall

bare bulb flash
set at f-8

f-8

meter for
shadow area

highlight
zone

window
light

Hasselblad camera
180 mm lens
exposure: f-8 at 1/60 second

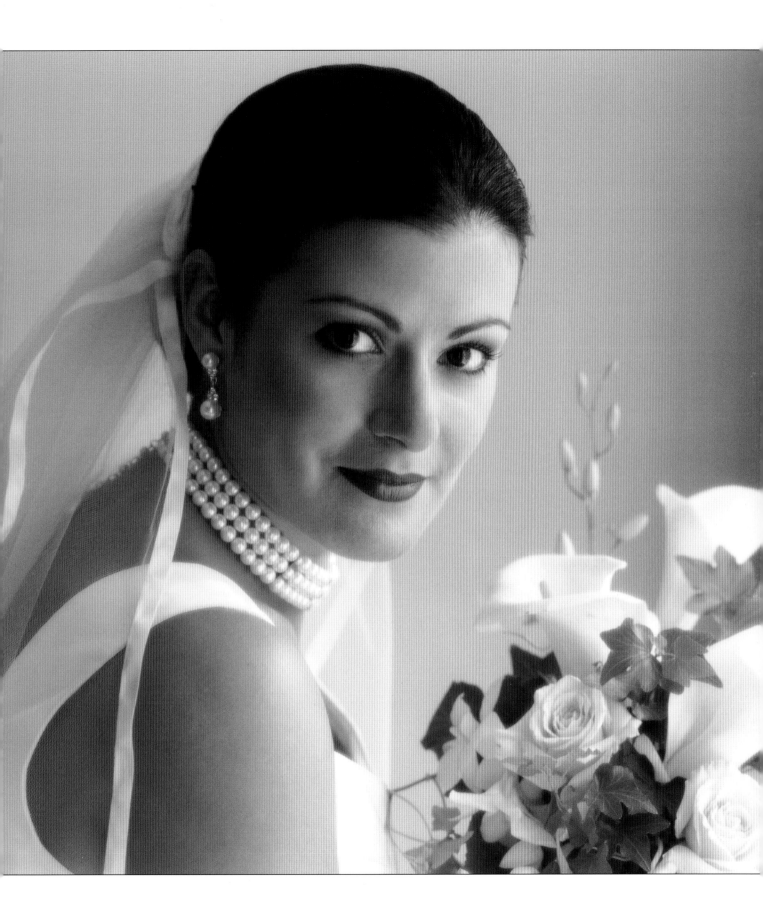

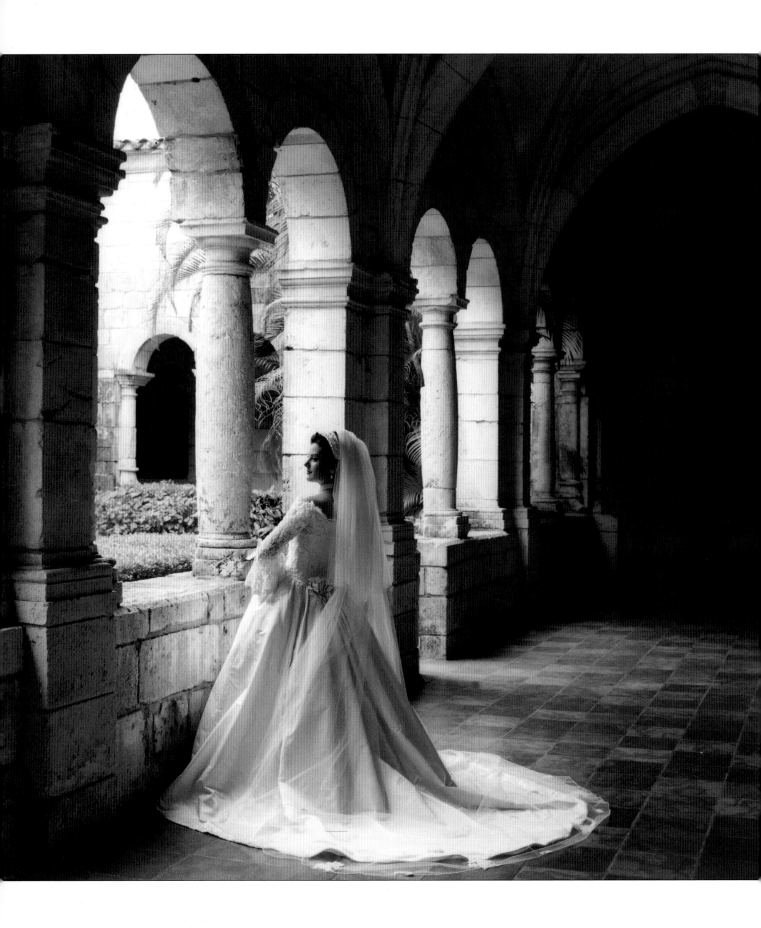

■ Architecture and Wedding Photography

Architecture can add a beautiful element to wedding photography. Throughout this book, you will find examples of subjects posed with windows, fireplaces, in wide views of the church, and (a favorite of mine) in archways. Adding these elements to your wedding images can help you set a mood in creative ways, offer you interesting lighting opportunities and certainly set your work apart from that of your competition.

■ Composition

I love to use a lot of perspective in my photography. This shows in compositions such as the one presented on the opposite page. Here, the bride does not fill the frame, but is instead placed in prominence amidst a deep field of beautifully carved stone archways. Notice how the heavy texture of the architecture contrasts with the smooth, soft curves of the bride's gown and delicate veil.

To compose a strong image within architecture, I start with the architecture. After all, you can't change that element and so must adapt what you can control (subjects, camera position, etc.) to work within it. With careful attention and practice, you can develop a good idea for scenes that will accommodate your subjects well, and a sense of how best to pose them.

If you decide to do architectural wedding images, take the time to scout out some nice locations and test them out. Take some Polaroids. Before you take a couple to the location, you should already have a few images planned and tested. Above all, when working with a client on images like these, allow yourself ample time. You will need to employ careful posing and lighting and will want the chance to work on several variations at the location of your choice.

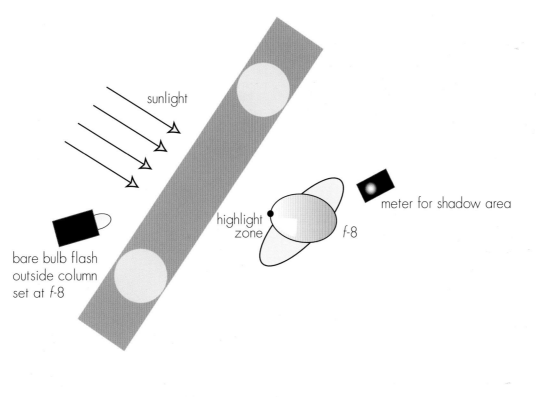

sunlight

meter for shadow area

highlight zone

f-8

bare bulb flash outside column set at f-8

Hasselblad camera
80 mm lens
exposure: f-8 at 1/60 second

▣ Types of Meters

There are three major types of light meters: reflected, incident and flash (or strobe). Whatever type you choose, and whether you are shooting in natural or artificial light, proper use of a high quality light meter will allow you to translate the light around you into emotions on your film.

▣ Reflected Light Meters

Reflected meters simply measure the amount of light that is reflected from a subject. To get an exact reading, hold the meter near your subject and direct it at the subject (or area of the subject) you are shooting. Remember, different areas of the subject will have different readings (for instance, this bride's hair and gown would read differently). Reflected meters are programmed to give an "average" exposure for the area metered. Therefore, metering for the bright white dress would result in underexposure on this bride's hair. Metering for her hair would result in overexposure of her dress. You should meter for a middle toned area, such as the face. You can balance for the highlight and shadow ratio from here.

Reflected meters usually have about a 30-50° angle of view, about the same as the angle of view as a normal focal length lens. A variation on reflected meters, called a

spot meter, is used in the same way but has only a 5° angle of view, allowing for more specific metering of a desired area.

▣ Incident Light Meters

Incident light meters measure the amount of light reaching the subject (i.e. the overall lighting condition around the subject). When using an incident light meter, the readings would remain constant whether metering this bride's hair or gown, since the light is measured before it is reflected. To use this type of meter, hold it near the subject and direct it toward the main light source. If metering for one specific source, make sure not to let light from another source fall on the meter. This may require shading the meter from one source with your hand,

▣ Flash or Strobe Meters

Flash meters measure the actual amount of light coming from your flash. I use the Minolta IV, which I find to be both accurate and durable. This is one of the most important things you can invest in.

To help you meter each shot accurately, I have indicated in each lighting diagram the position from which the shot was metered.

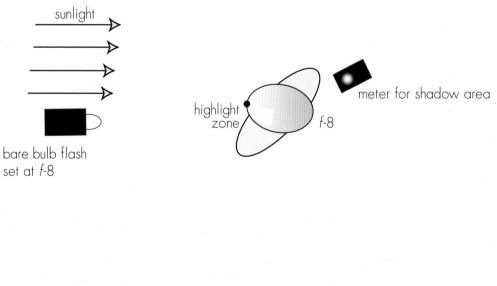

sunlight

bare bulb flash
set at *f*-8

highlight zone *f*-8

meter for shadow area

Hasselblad camera
180 mm lens
exposure: *f*-8 at 1/125 second

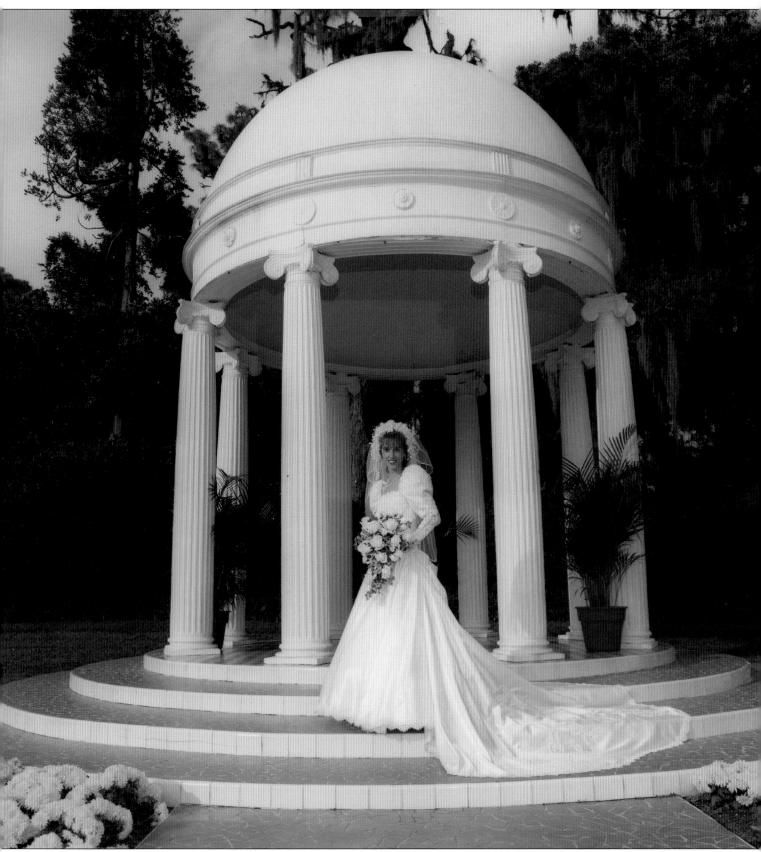

Cypress Gardens, Florida

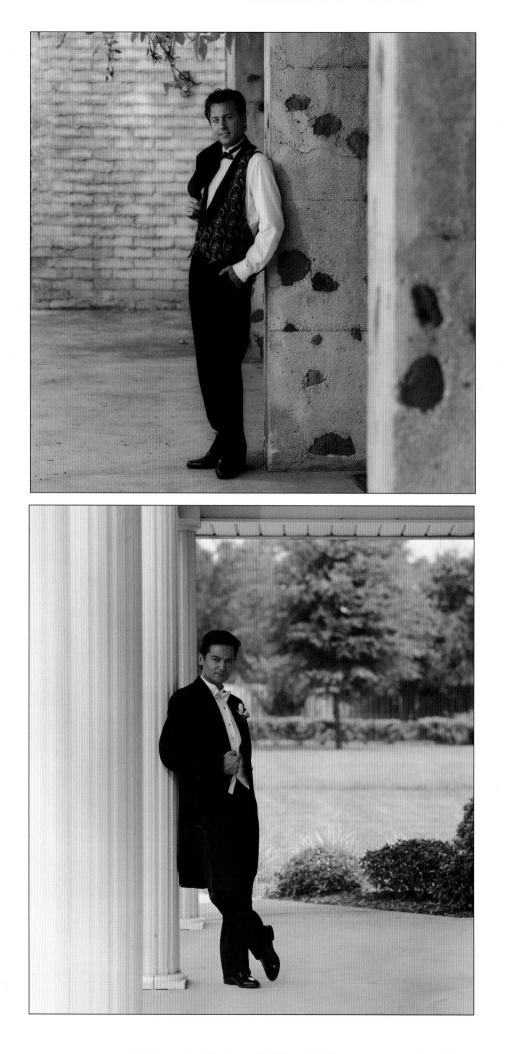

▉ Toning Your Prints

If you have your own black & white lab at home or in your studio, give some thought to offering toned prints for inclusion in the wedding album. Although most toning materials are not light sensitive, it is still better done in a well ventilated darkroom, as the toners can easily stain. The basic procedure for sepia toning involves bleaching the print, immersing it in toner, and washing. Detailed procedures vary from product to product, so be sure to follow the specific instructions of the product you are using.

▉ Safety

When toning, be sure to wear not only rubber gloves, but also goggles to protect your eyes. Working in a well ventilated area is also imperative.

▉ Getting Started

Some toners require that the print be bleached before toning. Commercial products are available, or a simple bleaching agent can be made by combining 50g potassium ferricyanide and 50g potassium bromide. Dissolve the mixture in enough water to make at least 500ml of solution. Then dilute it in a 1:9 ratio before using. Immerse the print in the bleach solution for one to two minutes until the image has almost disappeared. Then wash the print for the same duration. After washing, immediately immerse the print in the toning solution. Again, you may choose to use a commercial toner (in which case, follow the instructions provided on it), or you can mix a toner using 25g sodium sulphide dissolved in water to make 500ml. Toning the print may take as little as one minute for resin-coated prints, or as much as ten for fiber-based prints. You may wish to run a test strip before doing your actual print. From the toning solution, transfer the print to the wash tray. Wash at least five minutes if resin-coated, thirty if fiber-based. Hang to dry, or dry in a print dryer set for air only (no heat).

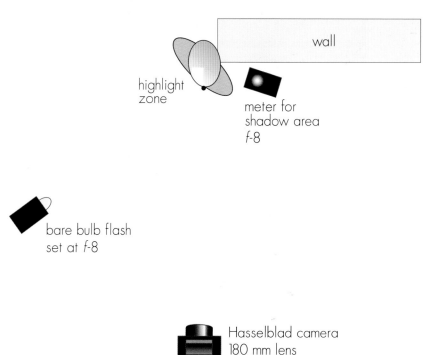

wall

highlight zone

meter for shadow area
f-8

bare bulb flash
set at *f*-8

Hasselblad camera
180 mm lens
exposure: *f*-8 at 1/60 second

■ Bare Bulb Lighting

Bare bulb flash lighting gives you a subtle way to add another layer of light in the highlight zone and open up the shadow area. It is a versatile technique with applications indoors and out, and with many qualities of light.

Indoors, as in this photo, bare bulb lighting provides nice highlights and opens up shadow areas. On a totally cloudy day with very flat lighting, bare bulb flash can provide a better degree of shade and allow you to better depict shapes and textures. On a beautiful clear day with lots of sunshine, you can pose your model with the sun behind him or her and use the bare bulb flash to match the exposure on the front of the subject to the area behind.

■ Metering

Metering to combine bare bulb flash with ambient light is quite simple. The important thing to keep in mind is to meter for the shadow side of your subject. Then, simply dial the correct f-stop on your flash. Remember to take off your reflector. Direct the bare bulb at the subject, making sure to keep it out of view of the camera lens. This church had windows on each side, so there was plenty of available light to work with.

■ Setting

I like to take the groom away from the stage area and shoot him wide open (f-4 or f-5.6). This image was shot with a 180mm lens, but I also love a 50mm (wide angle)—especially with a high ceiling.

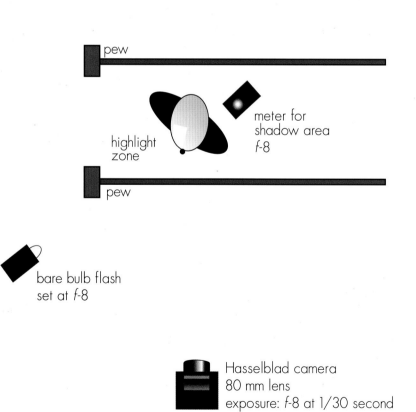

pew

highlight zone

meter for shadow area
f-8

pew

bare bulb flash
set at f-8

Hasselblad camera
80 mm lens
exposure: f-8 at 1/30 second

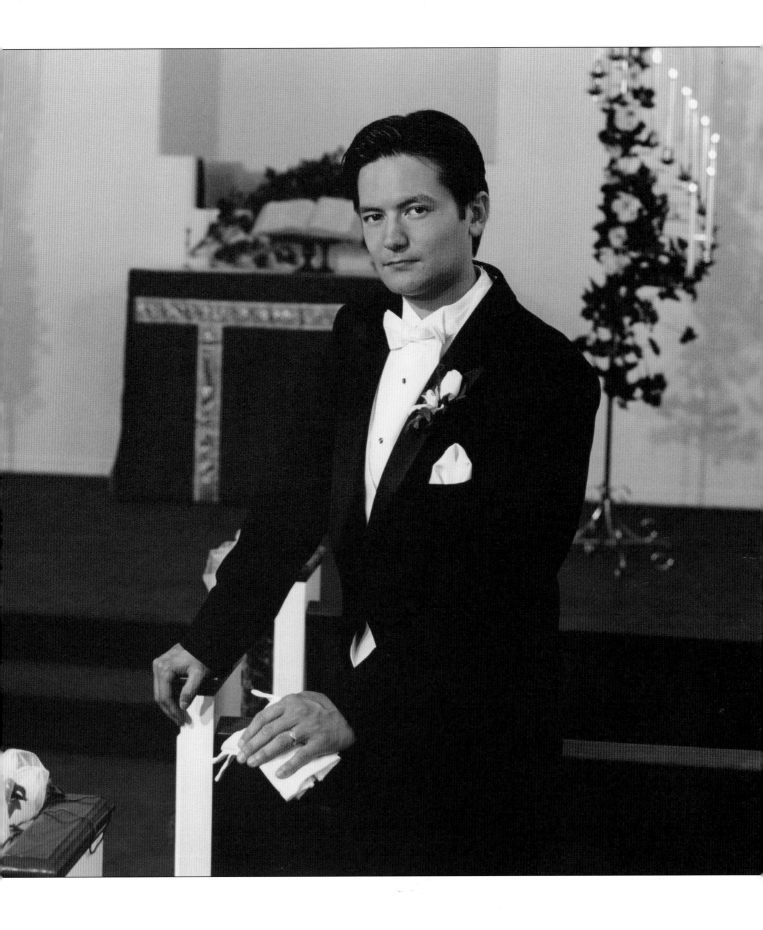

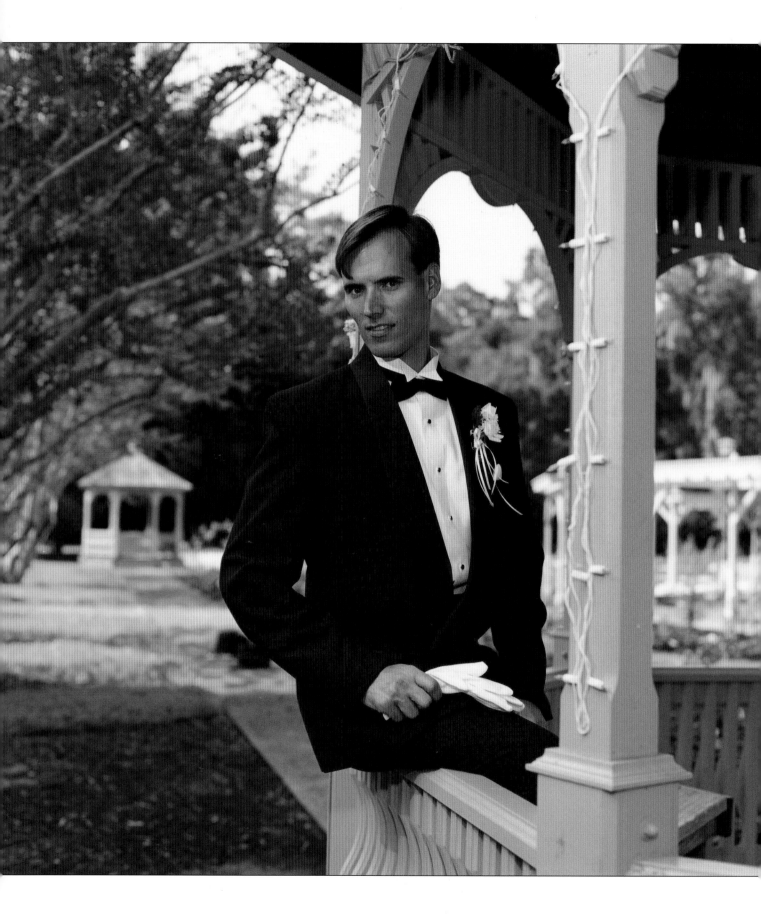

Posing the Groom

For this pose, the groom was seated in a picturesque gazebo with his body turned away from the light which came from the left side of the frame. When using a seated pose, make sure to have to groom sit straight and tall – slouching will look terrible. The groom's face was turned into the light, and his hands were carefully posed. Having him hold his gloves will give the groom something to do with his hands and add a nice detail to the shot.

Composition

Getting the location right was a little tricky. I wanted to pose the groom in an area where I'd be able to show part of the gazebo in which he was seated in the foreground, but also include another gazebo in the background to add a sense of depth and perspective. In order to get the right angle, I had to stand on a four-foot step ladder. This put me on a more level angle with the groom. One of the aspects of this shot I especially like is the way the tree branches sway into the frame.

Shooting

When you set up a shot like this, the image of the groom alone shouldn't be the only one you shoot. For instance, consider adding the groomsmen in the background and out of focus. Or, add the bride, looking lovingly at her new husband. Adding these subjects to the background and allowing them to go out of focus could create a very dramatic series of images.

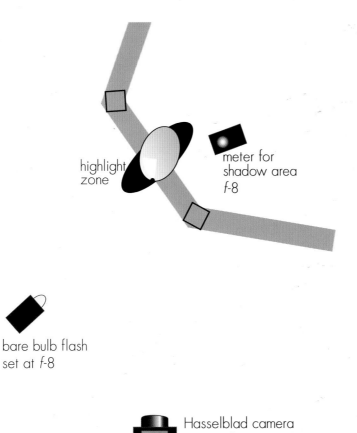

highlight zone

meter for shadow area
f-8

bare bulb flash
set at f-8

Hasselblad camera
180 mm lens
exposure: f-8 at 1/250 second

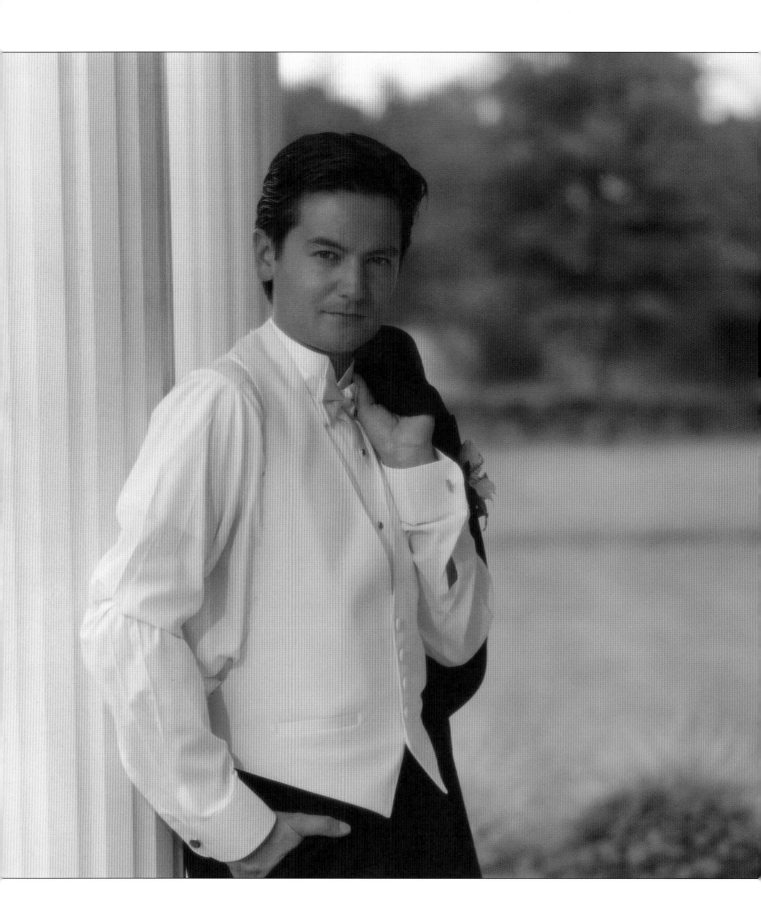

■ Styling the Groom

When setting up a shot like this, I have my assistant do the styling. We call this a "GQ Shot," a stylish photo of the groom – and one with a little attitude created by having him throw his coat over one shoulder.

■ Composition

As in most of my shots, the subject is not placed in the center of the frame. This lets the row of columns lead your eye to him, and make a more interesting image. Additionally, the extra space to the right side of the frame gave me space to move some additional subjects in and out of frame without moving the groom. For one shot I added the bride, looking at her husband and slightly out of focus. Another great shot was done with the parents in the right half of the frame, and also out of focus. You could even pose the groomsmen back there, and have them casually looking at each other for yet a different feel. Keep your eyes open for situations in which you can do several images without having to set up all over again.

■ Environmental Images

While it would be nice to have unlimited time to work on environmental portraits, it's just not the case. Make images of the bride and groom your priority. These are the images that are most important to them. Then, if time permits, do further variations with the parents and the full wedding party.

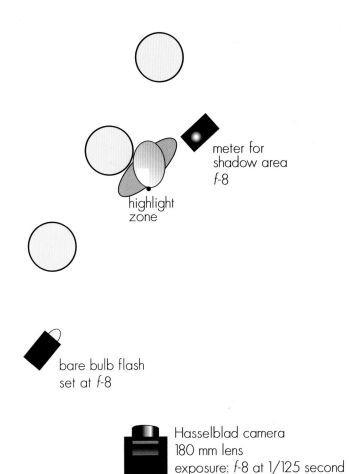

meter for
shadow area
f-8

highlight
zone

bare bulb flash
set at f-8

Hasselblad camera
180 mm lens
exposure: f-8 at 1/125 second

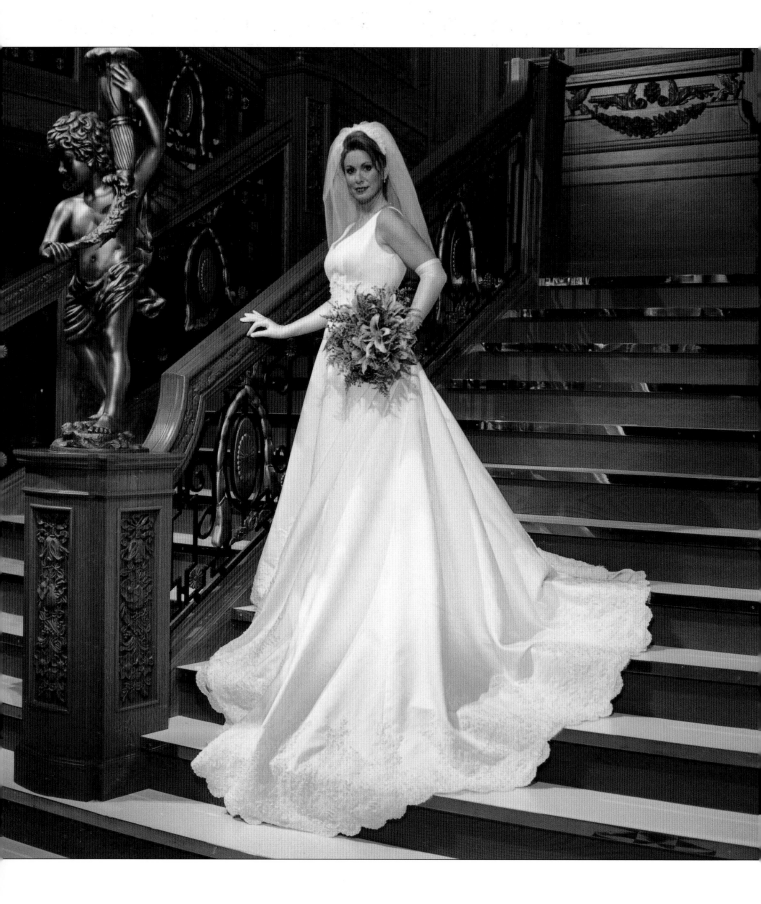

POSITION, POSE AND LIGHT

■ Location

This bridal portrait was created on the re-constructed grand staircase of the Titanic. If you've seen the movie *Titanic*, you'll recognize this as the location of quite a few chase scenes and grand entrances. As you can see, it's also a stunning location for a bridal portrait.

■ Basic Posing

With the bride in place on the stairs, this elegant pose was simple to create. The bride arched her back slightly and placed her weight on the foot farthest from the camera, causing that shoulder to drop slightly. Then, she simply turned her face toward the high shoulder. The next step was to pose her arms and hands gracefully.

■ Hand Posing

Don Blair, one of my most important mentors, told me once that a portrait is not proper until the hands are posed correctly. In this case, both of the bride's hands (the one holding the bouquet and the other, which rests lightly on the banister) were posed to create a classic S-curve. Notice especially how the wrist of her right hand is bent slightly, elevating the fingers and creating an elegant, feminine curve.

■ Styling the Gown

The bride has spent a lot of money to look her best on this important day – and a big chunk of that was spent on her gown. Because of this, it is extremely important to take the few seconds needed to make it look beautiful. Here the skirt was fluffed so that it fell cleanly and naturally, and the train was draped down the stairs to display its delicate scalloped edge.

■ Lighting

To create this exposure, I took an overall reading of the ambient light. It was f-8 at $1/8$ second using Kodak 400 Portra NC.

■ Main Light

No matter where I am creating portraits, either inside or outside, I always place the main light on the bride's side of the portrait. I then place the second light (for fill) over the camera and set it at one stop less than the main light. My goal is to create a 3:1 light ratio on the subjects. As you can see, this arrangement provides flattering light for both the bride and groom, and full detail on both the highlight and shadow areas.

■ Cake Cutting Sequence

The cake and cake cutting provide a nice opportunity for you to create a sequence of images for the album. I always start out by photographing the cake by itself. Often, I like to put the bridal bouquet next to it. Once I've photographed the whole cake, I also use my 180mm lens to create a close-up image of the cake top alone.

With these images done, it's time to proceed to the cake cutting. For these shots, I pose the bride and groom close together with their bodies turned in toward the cake (and toward each other). The couple's far arms are placed around each other, as you can see in each of these photographs. Together, both the bride and groom hold the cake-cutting knife in their hands closest to the camera. The first photo is taken of the couple in this pose, looking into the camera. Next, without changing the pose, I have the couple look down at the cake. To continue the sequence, the couple begins to cut the cake (here, you may want to move your camera and take the shot from another angle). Once the cake is cut, I photograph the bride and groom feeding each other, and then kissing over the cake. For the last shot in the sequence, I simply turn around 180° and photograph the guests and their reactions to the cake cutting ceremony.

When you've shot all of these images, you should have a sequence of about eight portraits to uses in the couple's album. The result is increased sales for you, and a wonderful collage of the event for the couple.

The Wedding Party and Family

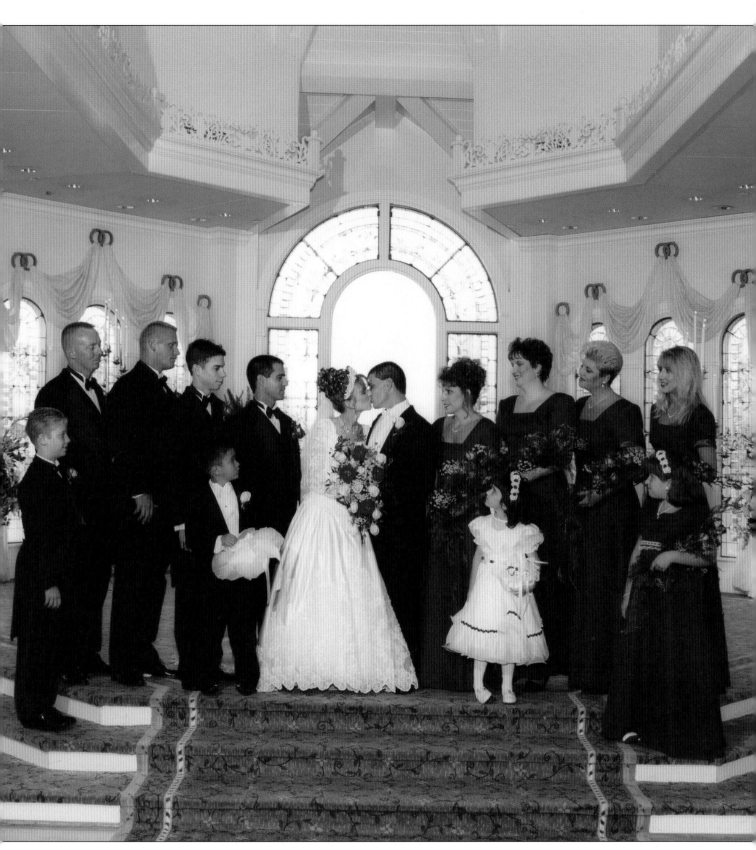

When the whole group has been arranged, have them turn their faces toward the couple. Clients love this image!

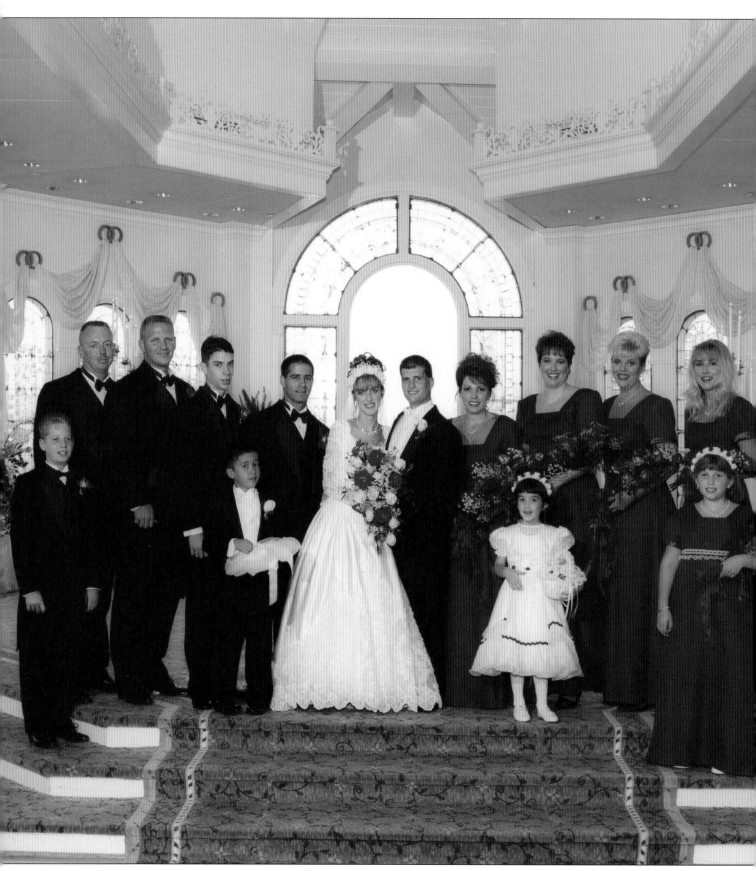

For this grouping, it's guys on the bride's side, and ladies on the groom's side — then spread out the kids to balance the image! As in all the group images, make sure the ladies are all holding their bouquets the same way in each frame.

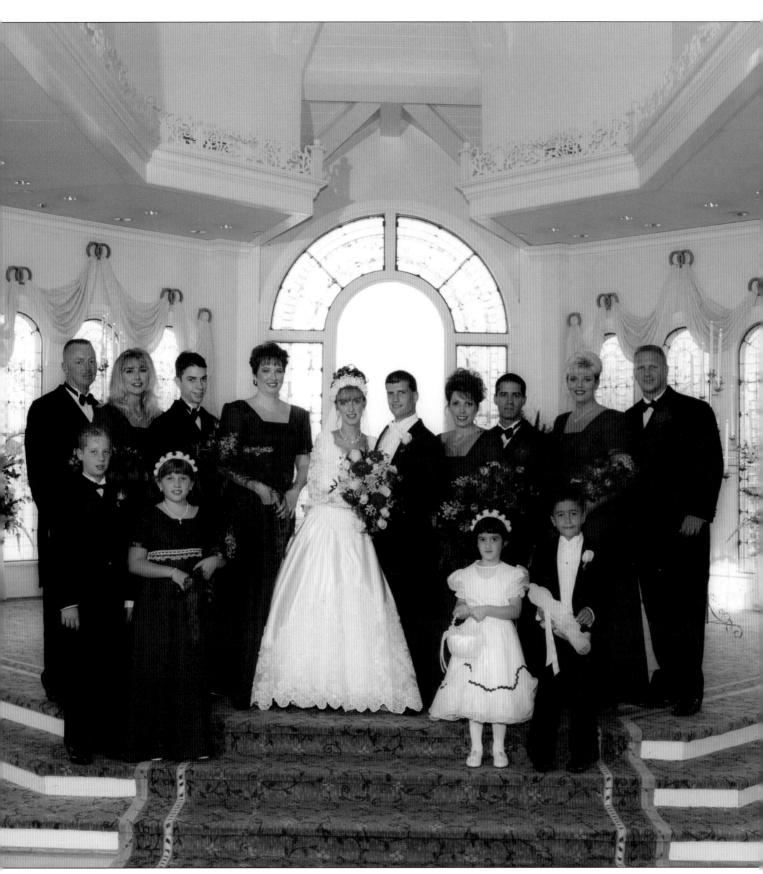

Here's a third variation on the wedding party – a boy, girl, boy, girl arrangement. The more set-ups you provide, the more you'll sell for the couple's album. If you come up with an efficient system (or refer to mine on page 29), you can do them all in a surprisingly short time.

◼ Posing

The stairs and lovely arched window provide a perfect setting for the wedding party portraits featured on pages 81-85.

The first portrait (pg. 85) features the entire group with the groomsmen on the bride's side, and the bridesmaids on the groom's side. The couple kisses with all of the wedding party looking on – notice especially how cute the kids are! The second portrait (pg. 86) shows the identical grouping, but with all the subjects facing the camera and smiling. In the third grouping, the couple remains placed, but all the couples (including the children) are arranged in couples and posed evenly around the newlyweds.

Note that in each of the portraits, the bride and groom remain in the same pose, while their attendants move around them. This is a good organizational technique for creating multiple images of the wedding party with a minimum of fuss.

◼ Maid of Honor

On her wedding day, the bride will have a lot of things on her mind, from the meaning of the commitment she is making, to the styling of her dress and hair, to the comfort of her guests. It can be a very stressful event for her. Part of the maid (or matron) of honor's job is to help the bride with every step of the process and keep her stress to a minimum. As such, before you arrange the area you intend to use for group photographs, you should ask the maid of honor to assist you with organizing the people in the party and styling the bride's gown. The maid of honor's help will be an excellent resource for you, and help to reduce demands on the bride

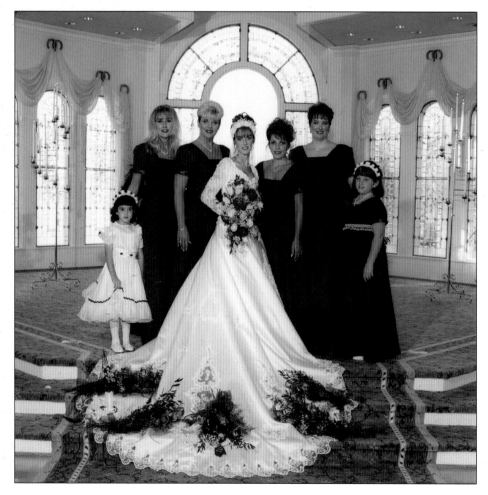

Opposite and Left: *These images show two variations on a similar grouping. For each photo, the bridesmaids were posed evenly on either side of the bride. The younger members of the bridal party were then placed to the left and right. For the pose on the opposite page, the bridesmaids hold their flowers and the girls are seated. For the smaller image on this page, the bouquets were arranged on the bride's train, and the girls were posed standing.*

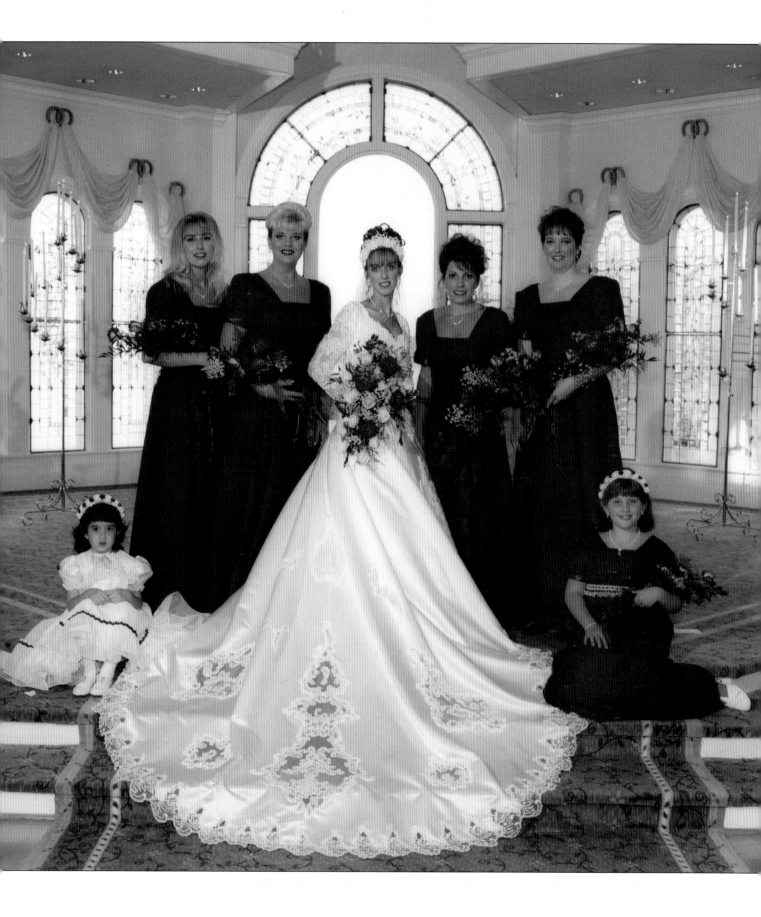

▪ Timing

When you are working on shooting the wedding party, time constraints will be a fact of life. The church may have another wedding or event scheduled after yours, or the group may just be eager to move on to the reception. Still, this is a very special event, and you should give yourself the time you need to capture the special images your clients will want. Here are a few helpful tips to keep in mind.

▪ Wedding Party

First, keep in mind that the members of the wedding party don't know your organizational techniques for shooting, and will need good, clear direction. You'll also need to give them time to get comfortably into position when you call them. Establishing a good, friendly rapport from the start will help create a quick but comfortable pace for shooting.

▪ Bride

Next, remember that the bride is the subject to whom you should devote the most time. She is the most important person in the images and you should arrange her first, styling her gown and veil with care and close attention. If possible (as in the examples on pages 85-89), move the wedding party around her to avoid having to constantly re-style.

▪ Children

Finally, when children are included in the wedding party, get them in right away. Youngsters will tend to get very restless when made to wait around for the grown-ups!

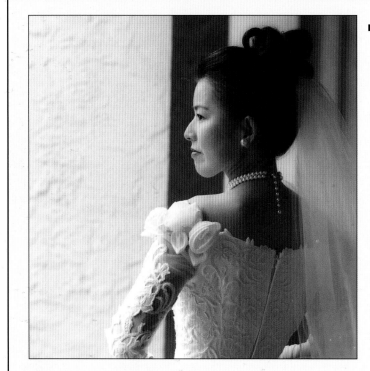

━Hints and Tips━

Establishing a good relationship with other professionals in the wedding businesses can be extremely beneficial. Developing a good rapport with these businesses will earn you recommendations, and even some other benefits. For instance, one of the most extravagant bridal collections in Orlando allowed us our choice of gowns to produce some of the images in this book.

Whether you are just getting started in wedding photography or are a working professional, building good relationships with other wedding service providers (such as bridal boutiques and florists) can provide many advantages. Doing a few shoots with models and borrowed gowns (then providing the loaning boutique with photos in return) can be a great way to promote your business and build your portfolio. It's also a great way to practice new ideas and build your skills.

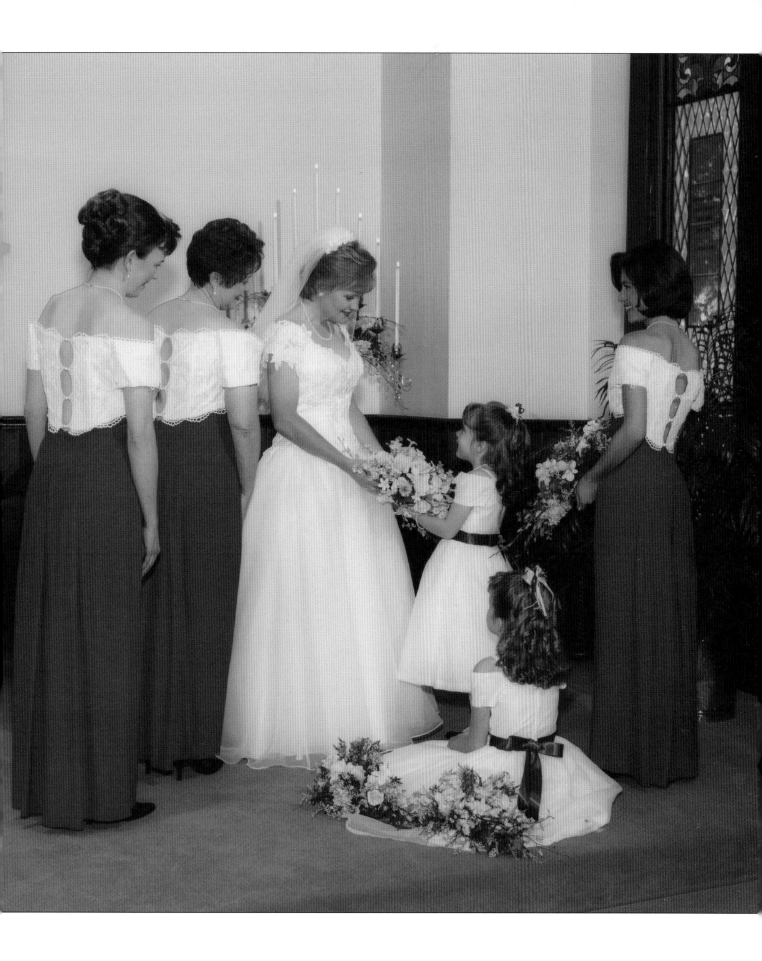

THE GUYS

■ **Before the Wedding**

When I'm doing pre-wedding photography on the day of the ceremony, I always allow a little extra time for the guys to show up late. Many times they'll head out early for a game of golf or "one last drink" with the groom as a bachelor. But even if they are late, you should try to get some nice group shots so you won't have to worry about taking them after the ceremony. These are great shots for the groom's parent album.

■ **After the Wedding**

When you're shooting the guys after the wedding, be prepared to deal with a bunch of groomsmen who just want to get on to the fun of the reception. The secret to dealing with this is to have fun with them, and let them have fun on the shoot. Gain their confidence, and let them know that if they'll give you a little quality time, you'll get them on to the reception as soon as possible. With a little planning and organization, you should be able to send them on their way in about half an hour.

■ **Location**

A large window behind the group provided nice backlighting that made this location appealing. Additionally, the furniture and fireplace make the shot look like it was taken in a living room and not in a hotel lobby.

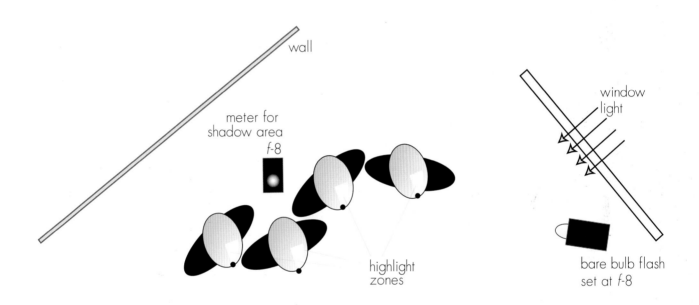

Hasselblad camera
80 mm lens
exposure: f-8 at 1/30 second

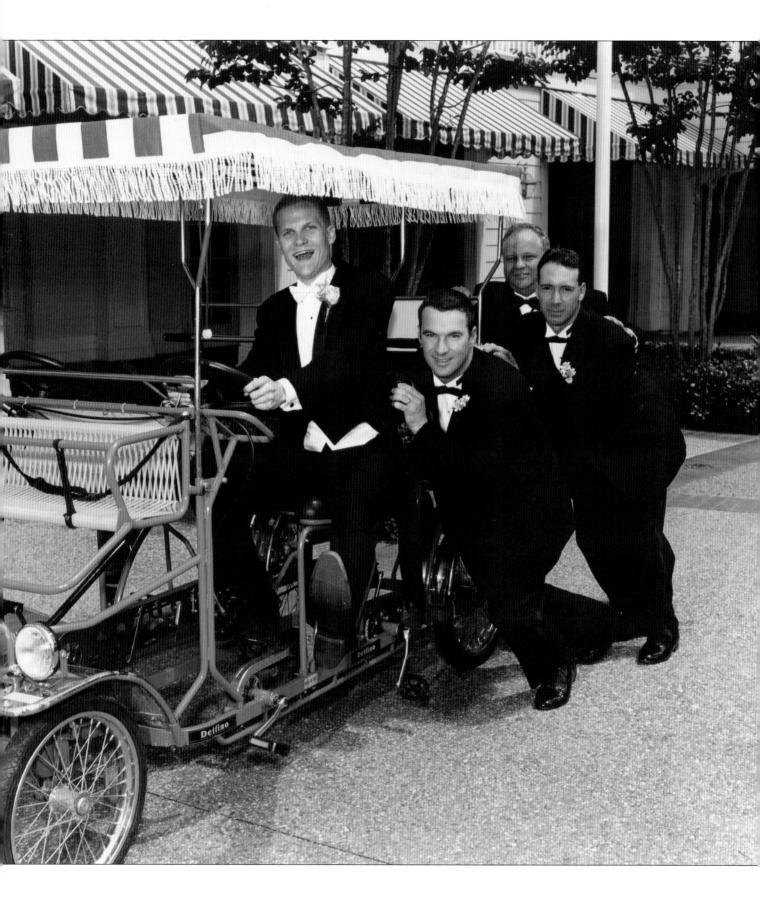

Fun with the Guys

As I mentioned on the previous page, having fun with the guys will make the shoot with them a lot more productive for all involved. Here's a great example of a fun shot that's full of energy and life – and a little nontraditional!

Posing

This shot was taken near a park in Orlando. The atmosphere at this wedding was fun, and the guys were fun to work with – something that shows in this image. Because the guys were all golfers, we did some creative images with the golf cart. This was one of them. In another shot, we posed the groom to pretend the cart wouldn't start,

and had the bride sitting nearby on a piece of luggage, looking on impatiently with her hands on her chin. There are a lot of fun shots you can do with a group of guys who are willing to work with you and have fun with it. One shot I like is the groom entering the doors of the church and all the groomsmen holding onto the tails of his coat, trying to keep him from walking down the aisle.

Lighting

The main light source is obviously the sun, but a flash was added (held by my assistant off camera) to add some specular highlights to the scene.

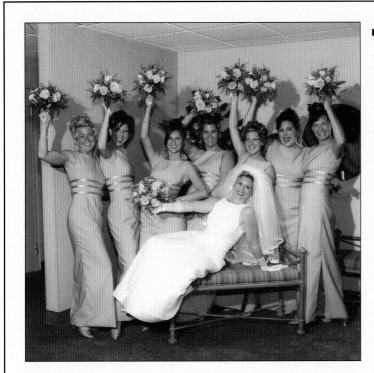

—Hints and Tips—

When you're shooting a fun and energetic group of people at a wedding, have fun with them! Once you've covered the traditional images the couple has specified, try out some creative ideas that will make memorable additions to their wedding album, and really reflect the character, joy and fun of the day. Get them caught up in the action, and capture those priceless moments!

Every wedding has its own unique character. Some wedding parties are more conservative and traditional, some want the day to be wild and fun. For more on this fun and dynamic group, and the image above, turn to page 99.

Learning Names

There are a lot of people involved with weddings, but at least it is imperative that you learn the names of the bride and groom, and perhaps their moms and dads. The maid of honor and the best man can also be important resources for you (helping with getting people organized and helping the bride and groom), so it wouldn't hurt to learn their names, too.

Tips for Shooting

During the group portrait phase of shooting, I like to take about 30 to 40 frames of each family. This usually takes between 30 and 45 minutes. By following a plan of action (review mine on page 29, and refer to the shot list beginning on page 117), this should be relatively painless. It varies from wedding to wedding based on the package the couple selects, but we generally shoot about 200 to 300 images for each wedding. The only time I bracket is when using slide film, but bracketing could raise this total. When shooting the group images, my assistant and I usually do about three shots of each grouping. We can't waste time, but better safe than sorry.

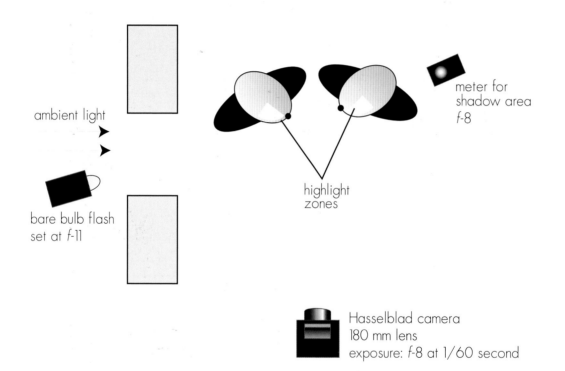

ambient light

bare bulb flash
set at *f*-11

highlight
zones

meter for
shadow area
f-8

Hasselblad camera
180 mm lens
exposure: *f*-8 at 1/60 second

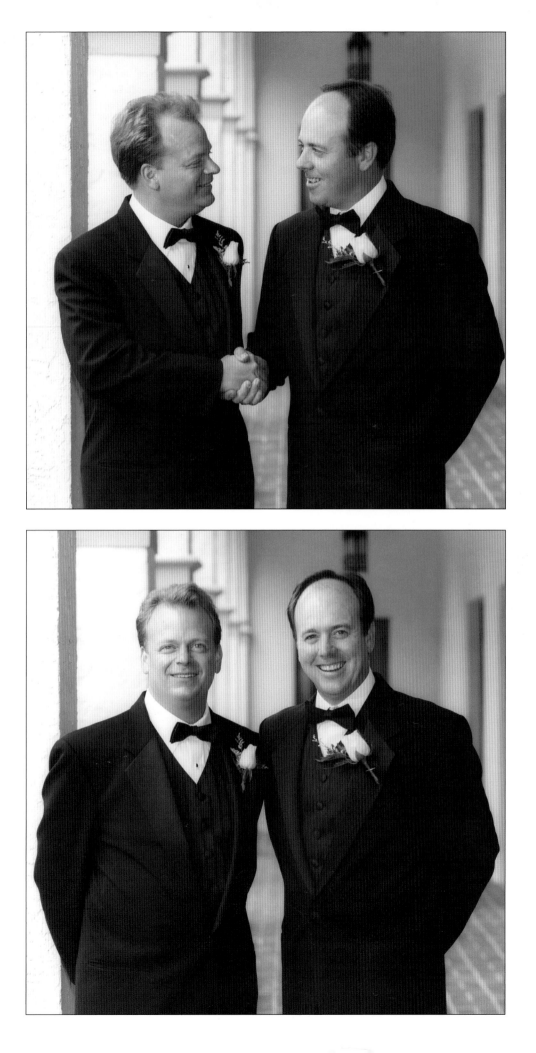

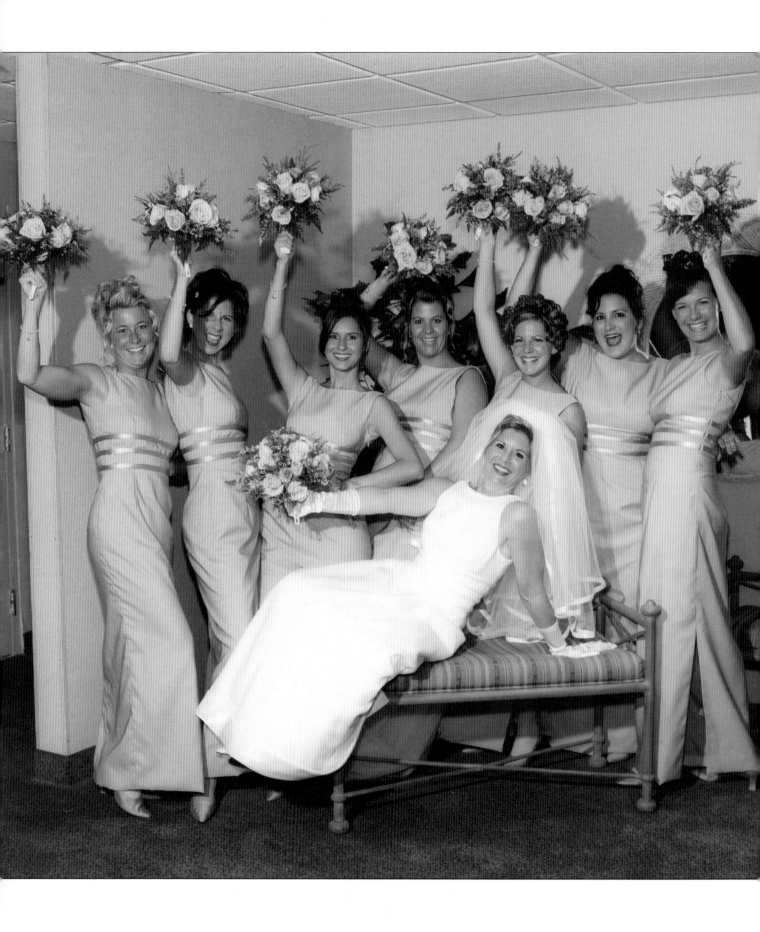

◼ A Memorable Wedding

What makes me happiest when shooting a wedding is when the event is well organized, runs on time and allows me to produce all the images I want to get for the couple. They are investing a lot of money in my talent, and when I can get creative and pull off 200 great images, that makes any wedding memorable. Wedding photography is something you need to put your heart into to be successful. Get involved emotionally with it, and make sure that when you leave a wedding you can say you did the very best you could – under any conditions.

◼ Candids

As you can tell, this bride's wedding was wild. We got a lot of great traditional photos (a few of which appear on pages 21 and 24), but what I'll never forget is the reception. She was dancing from the moment she walked in. Sometimes she was even too fast for the videographer. I shot over 300 candids at that reception! When you're shooting candids, you have to be able to have fun with the bridal party – catching those expressions is the whole purpose of candids.

◼ This Image

The bride wanted a shot with her sitting and her bridesmaids around her. The bride's fun-loving pose and the bridesmaids' raised flowers really helped capture the jovial and high-spirited mood of the event.

second flash at *f*-8 on monopod held by assistant

flash on camera at *f*-5.6

Camera with 80mm lens exposure: *f*-8 at 1/60 second

Before the Ceremony

The most important time for me as a wedding photographer is the two hours immediately preceding the actual ceremony. Since most modern brides don't want to see the groom before the ceremony, this is a perfect time create portraits of the bride and her family. It's also a good time to catch the bride with the special people we discussed and put on her special shot list during the pre-wedding consultation. This will help you free up time after the ceremony (when you will already have plenty to do!) and allow you to give the bride and her family your undivided attention.

The Bride's Family

I like to start off with the bride, bridesmaids, mom, dad and the bride's family. We do special shots, group shots and images with mom, dad, and mom and dad together.

As you can see from the series of images presented on the opposite page and the two following pages, you don't need to set up a totally different image for each grouping. Rather, choose a good location with nice light, then set up your equipment and move the groupings in and out systematically. Remember, the bride is the most important figure, so style her dress and veil carefully, then have her stay put. Then you can move the other members of the family in and out without having to re-style.

Since you will already have discussed with the bride the images she wants, you should be able to create an efficient plan for these groupings. Have your assistant call these out for maximum efficiency. You may wish to refer to the plan for altar formals on page 29 as a model. In addition, a very successful list of shots are included in the appendix on page 117.

I like to come up with about twenty-four images during this phase. Keep the bride's parent album in mind as you are working. The more images of their daughter you have to offer them, the greater your sales will be.

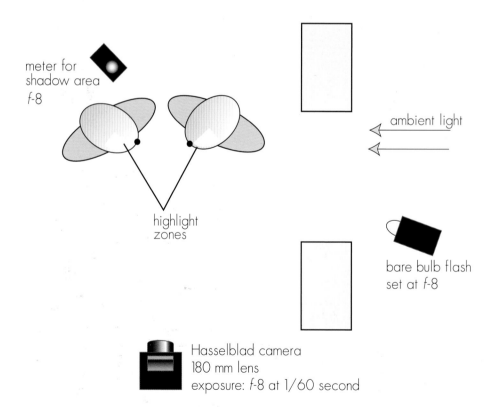

meter for shadow area f-8

highlight zones

ambient light

bare bulb flash set at f-8

Hasselblad camera
180 mm lens
exposure: f-8 at 1/60 second

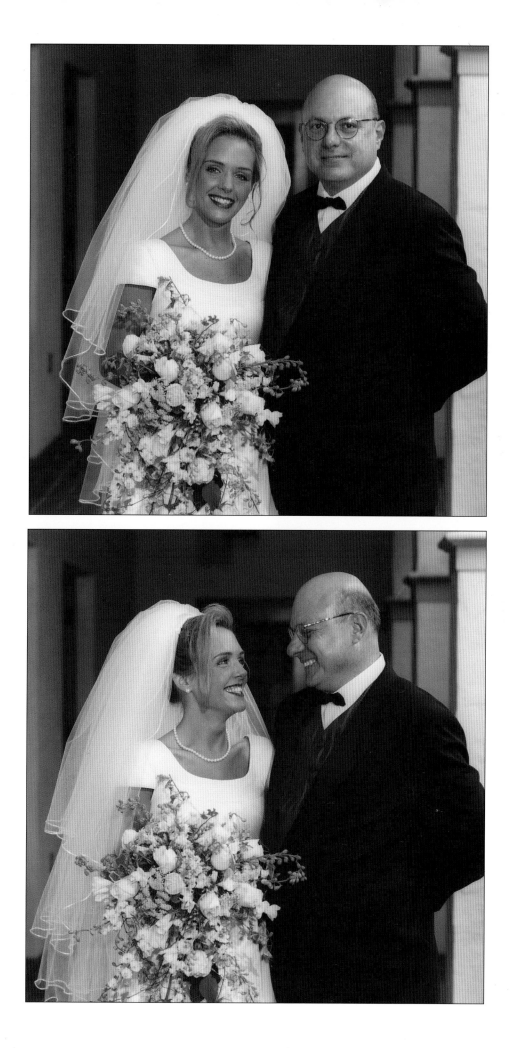

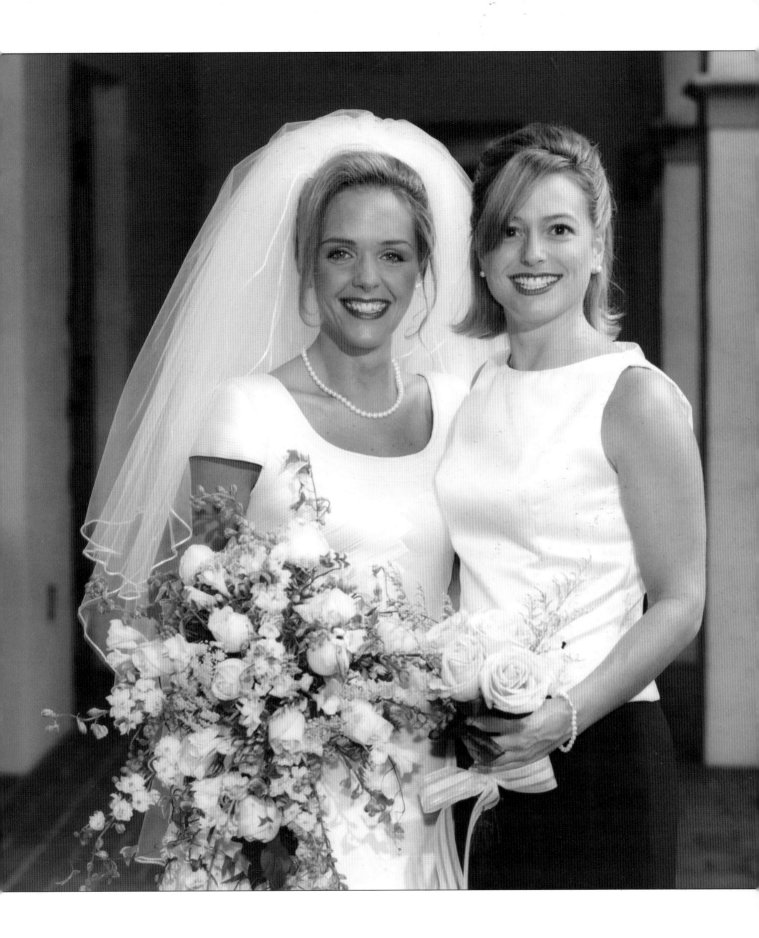

Double weddings mean double the fun – and double the challenge for the wedding photographer! One couple wants a particular look, while the other is looking for something different. What do you do? It's easy – relax, have fun and do something different! Work with both couples' needs and you'll come up with something they'll all love.

Chapter

Five

CREATIVE
TECHNIQUES

Uniquely

Styled

Portraits

■ A Creative Viewpoint

Double exposures can allow to you create an interesting sense of the surroundings of the ceremony. You capture the ceremony itself and the exterior of the church (or a meaningful piece of art, such as stained glass) all in one frame.

■ The Technique

Technically speaking, remember to leave enough negative unexposed that you'll have room to superimpose the second image. Choose subjects with dark backgrounds to avoid excessive bleeding of the images. Be careful also to avoid things like exit signs and candles which may run in from one image to the other.

■ Don't Promise Them

Double exposure shots can be rather time-consuming to set up, so don't promise your clients that you'll get them. Most of the time, you probably will be too busy getting the other, more important shots of the wedding.

Like most non-traditional images, double exposures go in and out of fashion. Relatively few couples ask for them today, but when I started wedding photography they were quite common. A favorite was the bride and groom superimposed in a glass slipper, or looking down on their own ceremony. Still, double exposures may be something you want to consider as an addition to your repertoire of wedding images.

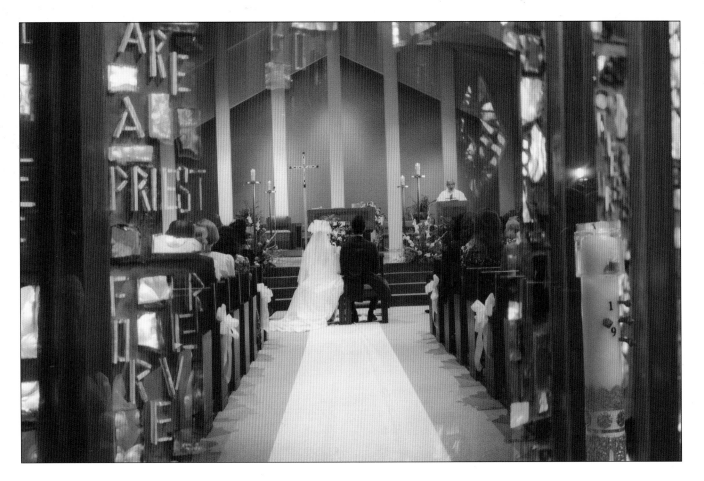

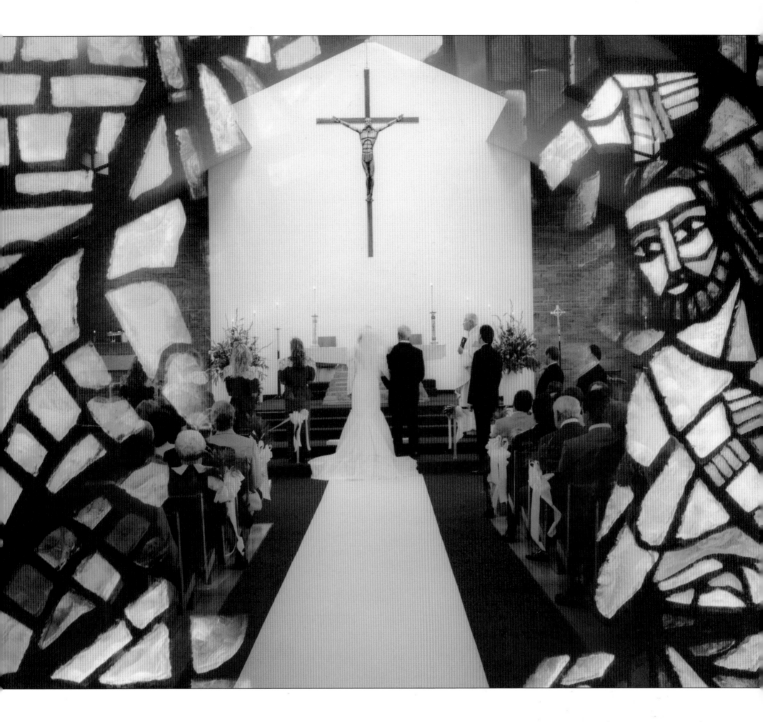

▣ Appeal

For every wedding we shoot, we try to capture at least one nice silhouette. A well done silhouette can be tremendously meaningful and elegant – and our clients love them.

▣ The Technique

Silhouettes can be accomplished anywhere you can create a strong contrast in light levels between the couple (in lower light) and the background (in higher light). You can do them outdoors against the sky, inside against stained glass, or even in an open doorway.

▣ Metering

For the shot on the opposite page, and the one on page 111, I metered the background only, creating a perfect silhouette. For the image on page 110, I metered the front of the faces, allowing the backlight to shine through. Notice the beautiful triangle of light this creates on the bride's cheek.

▣ Composition

The key to silhouettes is not to overdo them. The detail and tonal range of a regular image is not present in a silhouette. Keep to simple subjects, like the newlyweds posed in an elegant profile.

Look for pleasing shapes and simple, dramatic poses. Try having the couple kiss, or have the groom look into his bride's eyes and place his hand on her chin. You should also try something like the full length image on page 111, where a sense of dance was added to the couple's pose. Notice how beautifully their fluid lines set them apart from the solid linear frame of the columns that flank them.

As you experiment, you'll probably come up with more interesting locations and poses for silhouettes. These popular and classic images are something I definitely recommend giving a try.

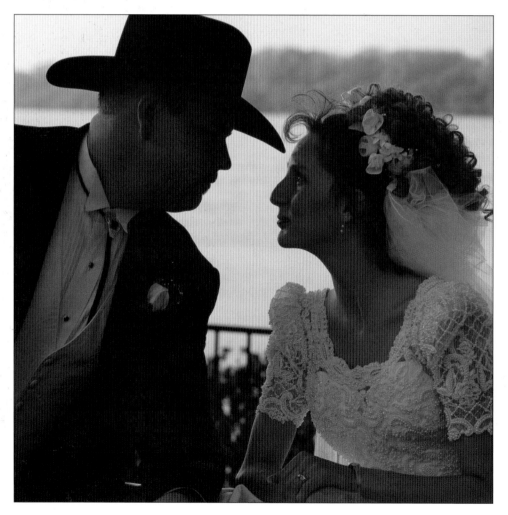

Left: *The key to silhouettes is not to overdo them. This silhouette was created by metering for the brighter, skylit area in the background behind the couple.*

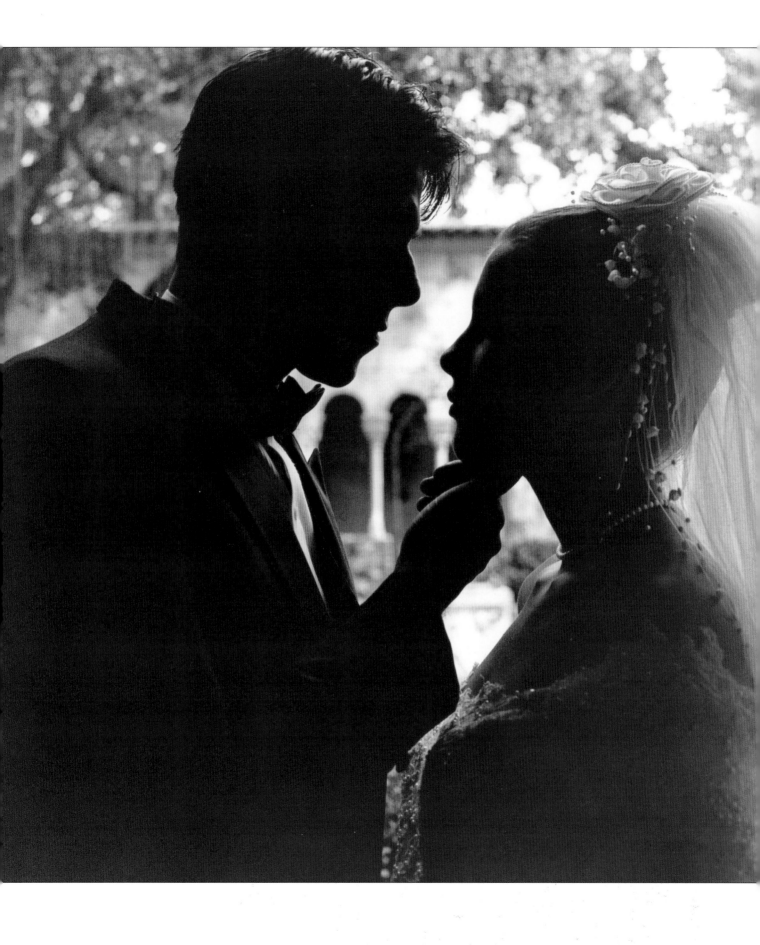

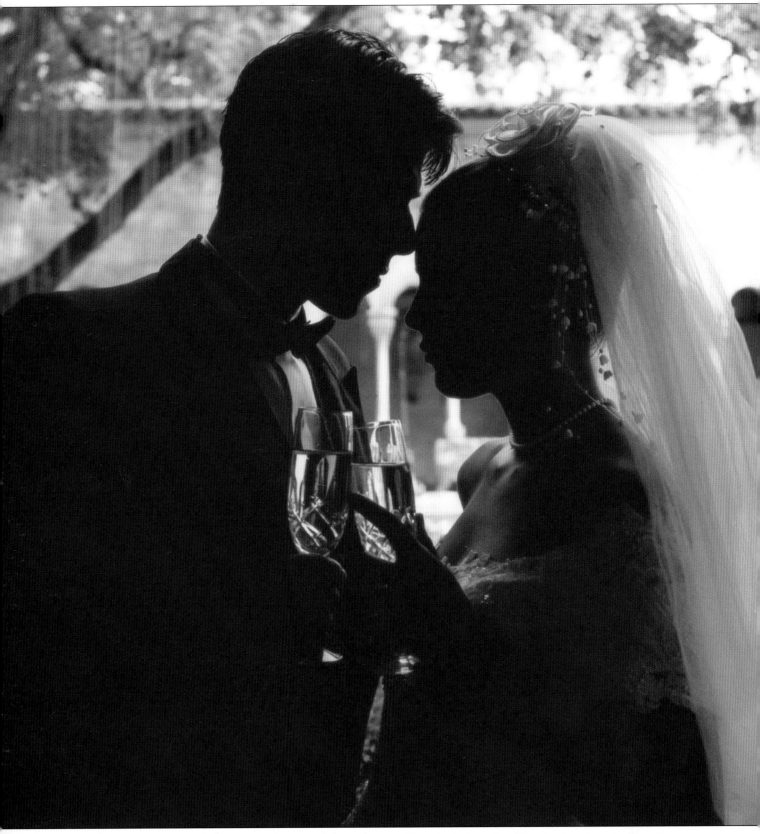

A well done silhouette can be tremendously meaningful and elegant – and our clients love them. The detail and tonal range of a regular image is not present in a silhouette, so keep to simple subjects like the newlyweds posed in an elegant profile.

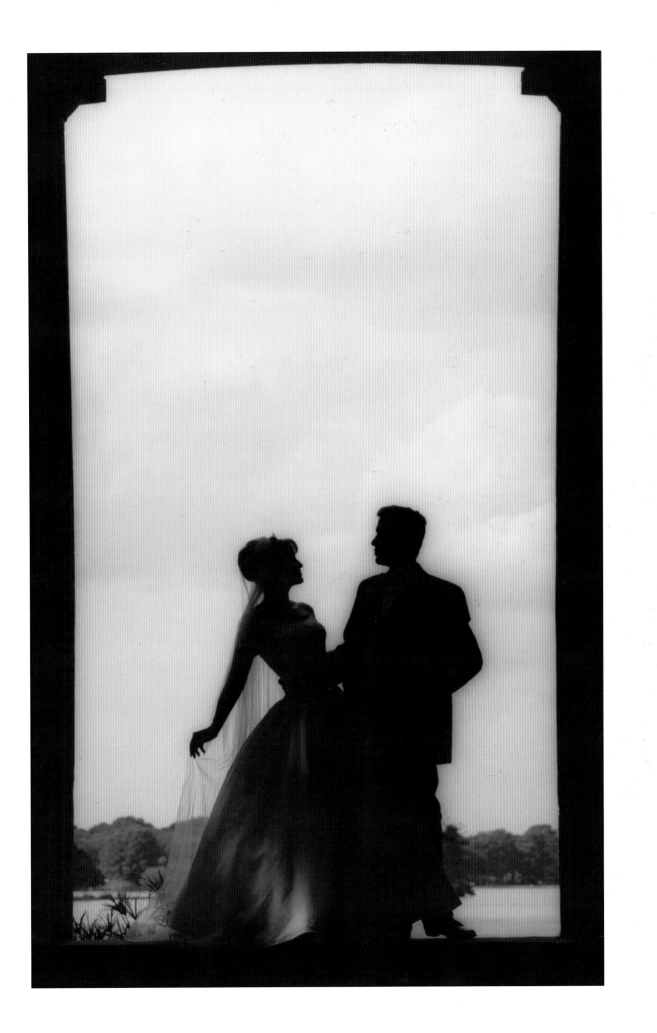

■ Low Key Images

For every bridal portrait session, we always do a low key image. You can see several more examples of low key bridal portraiture on pages 15-17. For our purposes in bridal portraiture, low key means nothing more than switching to a dark background. As you can see, the contrast between this dark background and the white bridal dress and veil creates a very striking and appealing image. It is a sophisticated look that appeals to many clients.

■ Lighting

I like to keep the lighting as simple as possible for low key images. For this image, the bride was placed in front of the black background. The main light was positioned at about a 45° angle to the right of the bride. A reflector was used to the left of the bride to add a little light to the shadow areas of her face. By all means, light up the veil as well, using a light source set for the same exposure as the fill light. Finally, remember to adequately use light to separate the subject from the backdrop.

■ Exposure

Low key lighting can be a bit trickier than middle or high key; the key is to provide enough light for a good exposure (I like to shoot between f-8 and f-11), but not so much that you start to lose detail. To meter properly, point your meter toward the main light source.

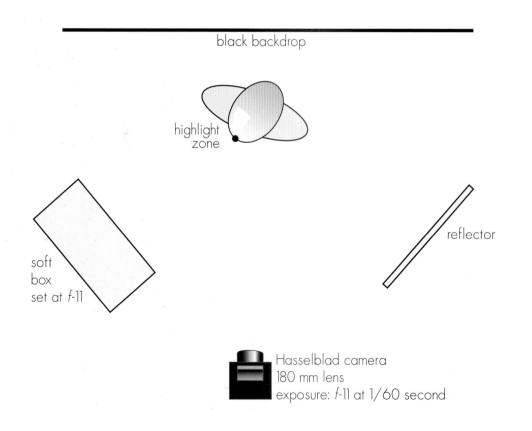

black backdrop

highlight zone

reflector

soft box set at f-11

Hasselblad camera
180 mm lens
exposure: f-11 at 1/60 second

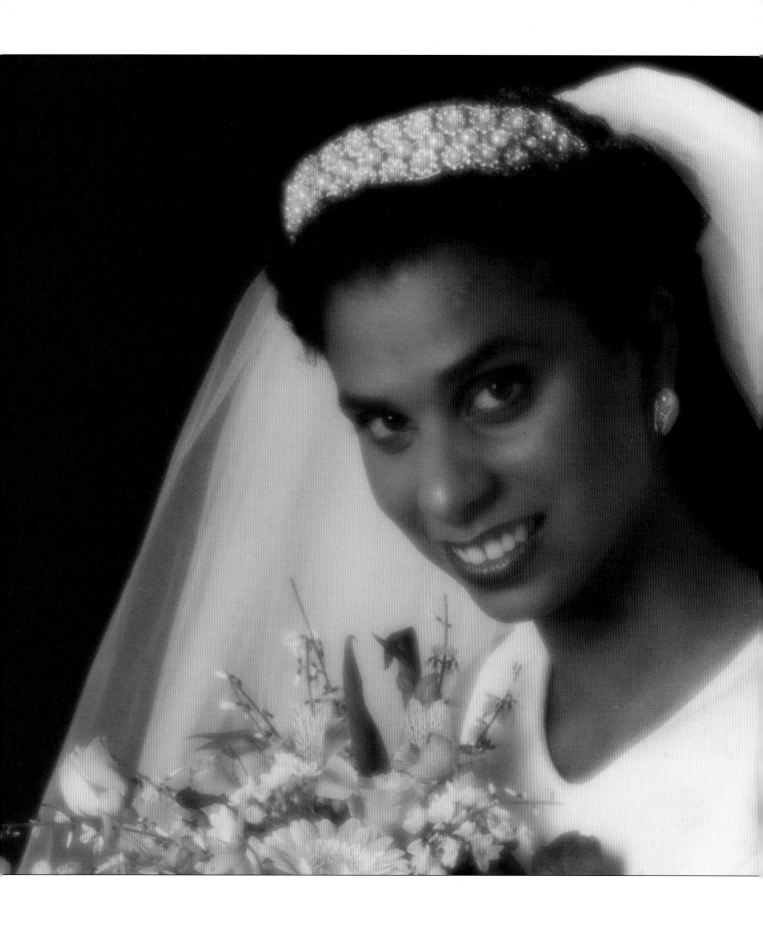

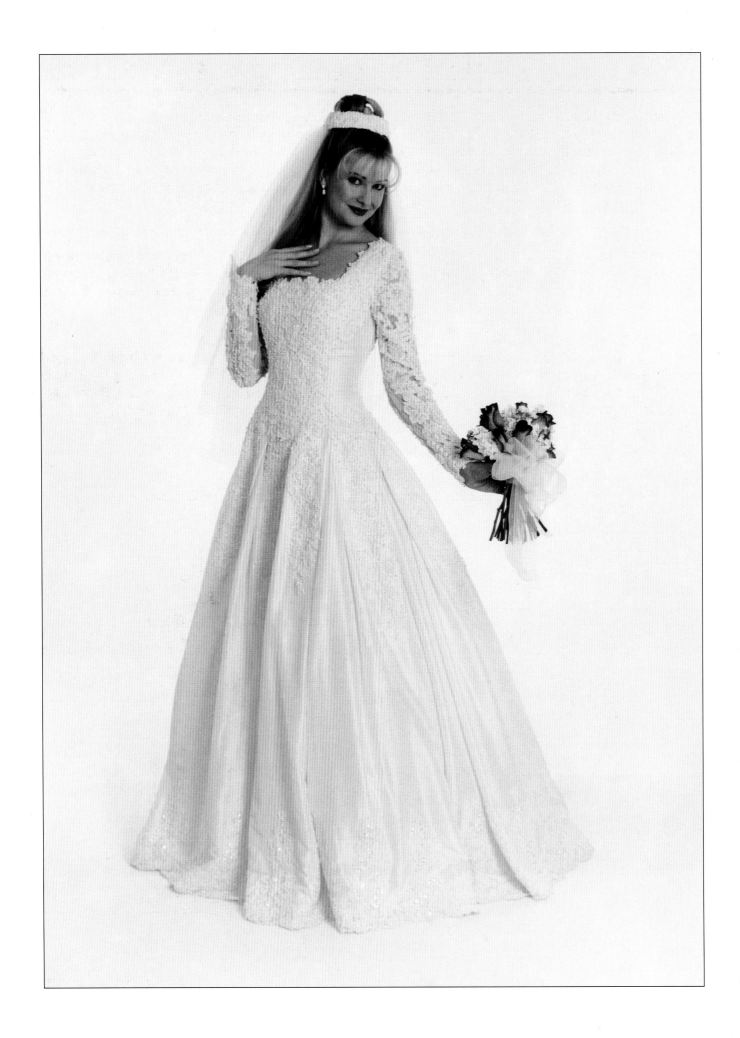

◼ High Key Lighting

The importance of the white bridal gown in the wedding tradition is reason enough to consider doing some high key portraiture. But high key images are also our number one seller – canvas, 20"x24", you name it, they want it. Clients call it white on white, but no matter what you call it, it sells.

◼ Shooting

I lowered the camera angle and shot mid-range for this shot. The lower camera angle makes the bride seem taller.

◼ High Key Lighting

The diagram below will help you set up the lighting for this beautiful, full-length shot of the bride and bouquet. Our studio is quite large, so this lighting set-up was appropriate. It is certainly possible, however, to create a beautiful high key portrait with other combinations of lights. For our set-up, the two back lights were set at *f*-16. Barndoors were used to prevent spill on the subject. The main light was set to ½ stop less (*f*-11½), allowing the backlights to create a totally white background. The fill light was set at *f*-8½.

◼ Processing

If your image isn't quite perfectly white (especially at the top or bottom where shadows could occur), you can ask your local lab to dodge these areas, leaving them pure white.

◼ Polaroids

We always take Polaroid tests before shooting. It's a good way to ensure that you know what you're going to get in your final image, and I recommend investing in the equipment to provide yourself with this option.

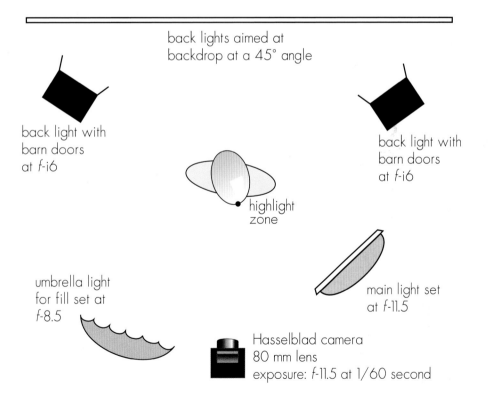

back lights aimed at backdrop at a 45° angle

back light with barn doors at *f*-i6

back light with barn doors at *f*-i6

highlight zone

umbrella light for fill set at *f*-8.5

main light set at *f*-11.5

Hasselblad camera
80 mm lens
exposure: *f*-11.5 at 1/60 second

APPENDIX

Suggested
Photo
List
for
Wedding
Photographers

You should plan to shoot these groupings and events at each wedding. Having a checklist with you at the wedding will help to ensure that you never forget an important shot, and that your shoot runs smoothly.

BRIDE
1. Bride full length
2. Bride full length profile (profile light)
3. Bride $^3/_4$ length
4. Bride $^3/_4$ profile (profile light)
5. Bride head and shoulders
6. Bride head and shoulders (profile with flowers)
7. Bride looking into mirror
8. Bride fixing her lips or blush ("set-up shot")

BRIDE WITH ATTENDANTS
9. Bride with each girl (full length)
10. Bride with each girl ($^3/_4$ with flowers)
11. Bride with each girl (looking at each other)
12. Bride with all bridesmaids in grouping
13. Bride sitting with bridesmaids around her

BRIDE WITH MOM
14. Bride with Mom (full length)
15. Bride with Mom ($^3/_4$ length)
16. Bride with Mom (looking at each other)
17. Bride and Mom fixing veil ("set-up shot")
18. Bride giving Mom a kiss

BRIDE WITH DAD
19. Bride with Dad (full length)
20. Bride with Dad ($^3/_4$ length)
21. Bride with Dad (looking at each other)
22. Bride fixing Dad's tie (turned in profile toward each other)
23. Bride giving Dad a kiss (Dad looks at camera)

BRIDE WITH FAMILY
24. Bride with Mom and sisters
25. Bride with Mom, sisters and Grandmother
26. Bride with Dad and brothers
27. Bride with Dad brothers and Grandfather
28. Bride with Mom and Dad
29. Bride with Mom, Dad, brothers and sisters
30. Bride with Mom, Dad, brothers, sisters and Grandparents
31. Bride with Grandparents

GROOM
32. Groom (full length)
33. Groom ($^3/_4$ length)
34. Groom profile (window light with bare bulb)
35. Groom in front of mirror fixing his tie (smile!)

GROOM WITH GROOMSMEN
36. Groom with each groomsman ($^3/_4$ length)
37. Groom with each groomsman (profile, shaking hands)
38. Groom with entire party of groomsmen

GROOM AND MOM
39. Groom and Mom (full length)
40. Groom and Mom ($^3/_4$ length)
41. Groom with Mom fixing his boutonniere or flower (profile)
42. Groom with Mom placing a kiss on his cheek
43. Groom with Mom ($^3/_4$ profile)
44. Groom placing kiss on Mom's cheek

GROOM AND DAD
45. Groom and Dad (full length)
46. Groom with Dad ($^3/_4$ length)
47. Groom shaking hands with Dad ($^3/_4$ length profile)
48. Groom shaking hands with Dad (looking into camera)
49. Groom fixing Dad's tie (profile)

GROOM WITH FAMILY
50. Groom with Mom and sisters
51. Groom with Mom, sisters and Grandmother
52. Groom with Dad and brothers
53. Groom with Dad, brothers and Grandfather
54. Groom with Mom and Dad
55. Groom with Mom, Dad, brothers and sisters
56. Groom with Mom, Dad, brothers, sisters and Grandparents
57. Groom with Dad and brothers
58. Groom with Dad, brothers and Grandfather
59. Groom with Mom and Dad
60. Groom with Mom, Dad, brothers and sisters

61. Groom with Mom, Dad, brothers, sisters and grandparents
62. Groom with sisters only
63. Groom with Grandparents

CEREMONY BEGINS

64. Parents coming down the aisle
65. Parents lighting candles
66. Each bridesmaid (separately)
67. Flower girl
68. Ring bearer
69. Bride and Dad before they walk down the aisle
70. Bride coming down the aisle
71. Bride kissing dad on altar
72. For Jewish weddings, Mom and Dad kissing bride before giving her away

CEREMONY (SPECIAL PHOTOS)

73. Full length images in back of church
74. Change lenses of existing light in ceremony
75. Go down to $^3/_4$ of aisle and repeat steps one and two.
76. Bride and groom lighting candles (shoot from back of church)
77. Bride and groom kneeling, usually facing each other
78. Bride and groom kissing
79. Bride and groom returning down the aisle
80. Bride and groom returning down the aisle (have them kiss – a great shot!)

RETURN TO THE ALTAR (SET-UP SHOTS)

81. Reshoot some key images with flash
82. Bride and groom on either side of minister (full length)
83. Bride and groom on either side of minister ($^3/_4$ length)
84. Bride placing ring on groom
85. Groom placing ring on bride
86. Bride and groom kissing

BRIDE AND GROOM FORMALS

87. Full length photos of bride and groom (about three)
88. $^3/_4$ length photos of bride and groom (about three)
89. Bride and groom looking at each other
90. Bride and groom with bride's parents
91 Bride and groom with bride's parents, brothers and sisters

92. Bride and groom with bride's parents, brothers and sisters and grandparents
93. Bride and groom with bride's parents, brothers and sisters, grandparents and anyone else special to the bride
94. Bride with her parents, brothers and sisters, grandparents and anyone else who is special to the bride
95. Bride with her parents, brothers and sisters and grandparents
96. Bride with her parents, brothers and sisters
97. Bride with her parents
98. Full length portraits of bride
99. Full length profiles of bride
100. As many variations as you can with the bride alone
101. Bride and groom with groom's parents
102. Bride and groom with groom's parents, brothers and sisters
103. Bride and groom with groom's parents, brothers and sisters and Grandparents
104. Bride and groom with groom's parents, brothers and sisters, Grandparents and anyone else special to the groom
105. Groom with his parents, brothers and sisters, grandparents and anyone else special to the groom
106. Groom with his parents, brothers and sisters and Grandparents
107. Groom with his parents, brothers and sisters
108. Groom with his parents
109. Groom alone (I like to take him to different areas of the church.)

BRIDAL PARTY SET-UPS

110. Bride with maid of honor
111. Groom with best man
112. Bride and groom in center with groomsmen on his side and bridesmaids on hers
113. Bride and groom in center with attendants paired up and posed evenly around them
114. Groom with groomsmen
115. Bride with bridesmaids

EXIT SHOTS

116. Leaving the church (try for some fun shots of the couple)
117. Bride and groom at the limousine
118. Bride and groom in the limousine

Newlywed Shots

119. Ring shot with groom in profile and bride in $^2/_3$ view

120. Look for an area where you can shoot with available light and do numerous shots of the couple (double profile, her profile to his, $^2/_3$ view, etc..)

121. Take the bride and groom to other locations — the more shots you have, the easier it will be for them to pick a big album (which means more sales for you)

Reception Photos

122. Dining area

123. Table set-up with flowers

124. Wedding cake (try adding extra flowers and backlighting)

125. Wedding party as they arrive (as couples)

126. First dance (four or five full length shots)

127. First dance ($^3/_4$ shot cheek to cheek — have your assistant backlight one stop less than your exposure)

128. Toast with the best man

129. Best man between newlyweds after toast

130. Blessing or cutting of the bread

131. Champagne toasts between members of the bridal party

132. Parents and family members toasting

133. Table shots (leave three or four people sitting, then bring the rest of those at the table around behind them)

134. Candids (work with the musicians and DJ's to know what activities are planned)

135. Candids of bride and groom walking around greeting guests

136. Dance shots

137. Bride dancing with father (full length)

138. Bride with dad ($^3/_4$ length, looking at camera)

139. Groom with mom (full length)

140. Groom with mom ($^3/_4$ length, looking at camera)

141. Bride and groom with Grandparents

142. Parents

143. Grandparents

144. Bridal party couples

145. The cake cutting

146. Bride and groom feeding each other

147. Bride and groom "cake kissing"

148. Bride taking off garter (at least two or three shots)

149. Groom about to toss garter

150. Bachelors trying to catch the garter

151. Bride with bouquet in the air

152. Women trying to catch the flowers

153. Goodbye shot

Other Books from
Amherst Media

Basic 35mm Photo Guide

Craig Alesse

Great for beginning photographers! Designed to teach 35mm basics step-by-step — completely illustrated. Features the latest cameras. Includes: 35mm automatic, semi-automatic cameras, camera handling, *f*-stops, shutter speeds, and more! $12.95 list, 9x8, 112p, 178 photos, order no. 1051.

Build Your Own Home Darkroom

Lista Duren & Will McDonald

This classic book teaches you how to build a high quality, inexpensive darkroom in your basement, spare room, or almost anywhere. Includes valuable information on: darkroom design, woodworking, tools, and more! $17.95 list, 8½x11, 160p, order no. 1092.

Into Your Darkroom Step-by-Step

Dennis P. Curtin

This is the ideal beginning darkroom guide. Easy to follow and fully illustrated each step of the way. Includes information on: the equipment you'll need, set-up, making proof sheets and much more! $17.95 list, 8½x11, 90p, hundreds of photos, order no. 1093.

Wedding Photographer's Handbook

Robert and Sheila Hurth

A complete step-by-step guide to succeeding in the world of wedding photography. Packed with shooting tips, equipment lists, must-get photo lists, business strategies, and much more! $24.95 list, 8½x11, 176p, index, b&w and color photos, diagrams, order no. 1485.

Lighting for People Photography, 2nd ed.

Stephen Crain

The up-to-date guide to lighting. Includes: set-ups, equipment information, strobe and natural lighting, and much more! Features diagrams, illustrations, and exercises for practicing the techniques discussed in each chapter. $29.95 list, 8½x11, 120p, b&w and color photos, glossary, index, order no. 1296.

Camera Maintenance & Repair Book 1

Thomas Tomosy

A step-by-step, illustrated guide by a master camera repair technician. Includes: testing camera functions, general maintenance, basic tools needed and where to get them, basic repairs for accessories, camera electronics, plus "quick tips" for maintenance and more! $29.95 list, 8½x11, 176p, order no. 1158.

Camera Maintenance & Repair Book 2

Thomas Tomosy

Build on the basics covered Book 1, with advanced techniques. Includes: mechanical and electronic SLRs, zoom lenses, medium format cameras, and more. Features models not included in the Book 1. $29.95 list, 8½x11, 176p, 150+ photos, charts, tables, appendices, index, glossary, order no. 1558.

Restoring the Great Collectible Cameras (1945-70)

Thomas Tomosy

More step-by-step instruction on how to repair collectible cameras. Covers postwar models (1945-70). Hundreds of illustrations show disassembly and repair. $34.95 list, 8½x11, 128p, 200+ photos, index, order no. 1573.

Big Bucks Selling Your Photography

Cliff Hollenbeck

A complete photo business package. Includes secrets for starting up, getting paid the right price, and creating successful portfolios! Features setting financial, marketing and creative goals. Organize your business planning, bookkeeping, and taxes. $15.95 list, 6x9, 336p, order no. 1177.

Outdoor and Location Portrait Photography

Jeff Smith

Learn how to work with natural light, select locations, and make clients look their best. Step-by-step discussions and helpful illustrations teach you the techniques you need to shoot outdoor portraits like a pro! $29.95 list, 8½x11, 128p, b&w and color photos, index, order no. 1632.

Make Money with Your Camera

David Arndt

Learn everything you need to know in order to make money in photography! David Arndt shows how to take highly marketable pictures, then promote, price and sell them. Includes all major fields of photography. $29.95 list, 8½x11, 120p, 100 b&w photos, index, order no. 1639.

Lighting Techniques for Photographers

Norm Kerr

This book teaches you to predict the effects of light in the final image. It covers the interplay of light qualities, as well as color compensation and manipulation of light and shadow. $29.95 list, 8½x11, 120p, 150+ color and b&w photos, index, order no. 1564.

Leica Camera Repair Handbook

Thomas Tomosy

A detailed technical manual for repairing Leica cameras. Each model is discussed individually with step-by-step instructions. Photo-graphic illustration ensures that every step of the process is easy to follow. $39.95 list, 8½x11, 128p, 130 b&w photos, appendix, order no. 1641.

Infrared Photography Handbook

Laurie White

Covers black and white infrared photography: focus, lenses, film loading, film speed rating, batch testing, paper stocks, and filters. Black & white photos illustrate how IR film reacts. $29.95 list, 8½x11, 104p, 50 b&w photos, charts & diagrams, order no. 1419.

Guide to International Photographic Competitions

Dr. Charles Benton

Remove the mystery from international competitions with all the information you need to select competitions, enter your work, and use your results for continued improvement and further success! $29.95 list, 8½x11, 120p, b&w photos, index, appendices, order no. 1642.

How to Shoot and Sell Sports Photography

David Arndt

A step-by-step guide for amateur photographers, photojournalism students and journalists seeking to develop the skills and knowledge necessary for success in the demanding field of sports photography. $29.95 list, 8½x11, 120p, 111 photos, index, order no. 1631.

Freelance Photographer's Handbook

Cliff & Nancy Hollenbeck

Become a freelance photographer or find tips to improve your current freelance business with this volume packed with ideas for creating and maintaining a successful freelance business. $29.95 list, 8½x11, 107p, 100 b&w and color photos, index, glossary, order no. 1633.

How to Operate a Successful Photo Portrait Studio

John Giolas

Combines photographic techniques with practical business information to create a complete guide book for anyone interested in developing a portrait photography business (or improving an existing business). $29.95 list, 8½x11, 120p, 120 photos, index, order no. 1579.

Infrared Landscape Photography

Todd Damiano

Landscapes shot with infrared can become breathtaking images. The author analyzes over fifty of his most compelling photographs to teach you the techniques you need to capture landscapes with infrared. $29.95 list, 8½x11, 120p, b&w photos, index, order no. 1636.

Fashion Model Photography

Billy Pegram

For the photographer interested in shooting commercial model assignments, or working with models to create portfolios. Includes techniques for dramatic composition, posing, selection of clothing, and more! $29.95 list, 8½x11, 120p, 58 photos, index, order no. 1640.

Professional Secrets of Advertising Photography

Paul Markow

No-nonsense information for those interested in the business of advertising photography. Includes: how to catch the attention of art directors, make the best bid, and produce the high-quality images your clients demand. $29.95 list, 8½x11, 128p, 80 photos, index, order no. 1638.

Computer Photography Handbook

Rob Sheppard

Learn to make the most of your photographs using computer technology! From creating images with digital cameras, to scanning prints and negatives, to manipulating images, you'll learn all the basics of digital imaging. $29.95 list, 8½x11, 128p, 150+ photos, index, order no. 1560.

Achieving the Ultimate Image

Ernst Wildi

Ernst Wildi teaches the techniques required to take world class, technically flawless photos. Features: exposure, metering, the Zone System, composition, evaluating an image, and more! $29.95 list, 8½x11, 128p, 120 b&w and color photos, index, order no. 1628.

Black & White Portrait Photography

Helen Boursier

Make money with b&w portrait photography. Learn from top b&w shooters! Studio and location techniques, with tips on preparing your subjects, selecting settings and wardrobe, lab techniques, and more! $29.95 list, 8½x11, 128p, 130+ photos, index, order no. 1626

The Beginner's Guide to Pinhole Photography

Jim Shull

Take pictures with a camera you make from stuff you have around the house. Develop and print the results at home! Pinhole photography is fun, inexpensive, educational and challenging. $17.95 list, 8½x11, 80p, 55 photos, charts & diagrams, order no. 1578.

Stock Photography

Ulrike Welsh

This book provides an inside look at the business of stock photography. Explore photographic techniques and business methods that will lead to success shooting stock photos — creating both excellent images and business opportunities. $29.95 list, 8½x11, 120p, 58 photos, index, order no. 1634.

Profitable Portrait Photography

Roger Berg

A step-by-step guide to making money in portrait photography. Combines information on portrait photography with detailed business plans to form a comprehensive manual for starting or improving your business. $29.95 list, 81/2x11, 104p, 100 photos, index, order no. 1570

Professional Secrets for Photographing Children

Douglas Allen Box

Covers every aspect of photographing children on location and in the studio. Prepare children and parents for the shoot, select the right clothes capture a child's personality, and shoot story book themes. $29.95 list, 8½x11, 128p, 74 photos, index, order no. 1635.

Telephoto Lens Photography

Rob Sheppard

A complete guide for telephoto lenses. Shows you how to take great wildlife photos, portraits, sports and action shots, travel pics, and much more! Features over 100 photographic examples. $17.95 list, 8½x11, 112p, b&w and color photos, index, glossary, appendices, order no. 1606.

Restoring Classic & Collectible Cameras (Pre-1945)

Thomas Tomosy

Step-by-step instructions show how to restore a classic or vintage camera. Repair mechanical and cosmetic elements to restore your valuable collectibles. $34.95 list, 8½x11, 128p, b&w photos and illus., glossary, index, order no. 1613.

Handcoloring Photographs Step-by-Step

Sandra Laird & Carey Chambers

Learn to handcolor photographs step-by-step with the new standard in handcoloring reference books. Covers a variety of coloring media and techniques with plenty of colorful photographic examples. $29.95 list, 8½x11, 112p, 100+ color and b&w photos, order no. 1543.

Special Effects Photography Handbook

Elinor Stecker Orel

Create magic on film with special effects! Little or no additional equipment required, use things you probably have around the house. Step-by-step instructions guide you through each effect. $29.95 list, 8½x11, 112p, 80+ color and b&w photos, index, glossary, order no. 1614.

McBroom's Camera Bluebook, 6th ed.

Mike McBroom

Comprehensive and fully illustrated, with price information on: 35mm, digital, APS, underwater, medium & large format cameras, exposure meters, strobes and accessories. Pricing info based on equipment condition. A must for any camera buyer, dealer, or collector! $29.95 list, 8½x11, 336p, 275+ photos, order no. 1553.

Fine Art Portrait Photography

Oscar Lozoya

The author examines a selection of his best photographs, and provides detailed technical information about how he created each. Lighting diagrams accompany each photograph. $29.95 list, 8½x11, 128p, 58 photos, index, order no. 1630.

Family Portrait Photography

Helen Boursier

Learn from professionals how to operate a successful portrait studio. Includes: marketing, advertising, working with clients, posing, lighting, and selection of equipment. Includes images from a variety of top portrait shooters. $29.95 list, 8½x11, 120p, 123 photos, index, order no. 1629.

The Art of Infrared Photography, *4th Edition*

Joe Paduano

A practical guide to the art of infrared photography. Tells what to expect and how to control results. Includes: anticipating effects, color infrared, digital infrared, using filters, focusing, developing, printing, handcoloring, toning, and more! $29.95 list, 8½x11, 112p, order no. 1052

Camcorder Tricks and Special Effects, *revised*

Michael Stavros

Kids and adults can create home videos and mini-masterpieces that audiences will love! Use materials from around the house to simulate an inferno, make subjects transform, create exotic locations, and more. Works with any camcorder. $17.95 list, 8½x11, 80p, order no. 1482.

The Art of Portrait Photography

Michael Grecco

Michael Grecco reveals the secrets behind his dramatic portraits which have appeared in magazines such as *Rolling Stone* and *Entertainment Weekly*. Includes: lighting, posing, creative development, and more! $29.95 list, 8½x11, 128p, order no. 1651.

Essential Skills for Nature Photography

Cub Kahn

Learn all the skills you need to capture landscapes, animals, flowers and the entire natural world on film. Includes: selecting equipment, choosing locations, evaluating compositions, filters, and much more! $29.95 list, 8½x11, 128p, order no. 1652.

Photographer's Guide to Polaroid Transfer

Christopher Grey

Step-by-step instructions make it easy to master Polaroid transfer and emulsion lift-off techniques and add new dimensions to your photographic imaging. Fully illustrated every step of the way to ensure good results the very first time! $29.95 list, 8½x11, 128p, order no. 1653.

Black & White Landscape Photography

John Collett and David Collett

Master the art of b&w landscape photography. Includes: selecting equipment (cameras, lenses, filters, etc.) for landscape photography, shooting in the field, using the Zone System, and printing your images for professional results. $29.95 list, 8½x11, 128p, order no. 1654.

Wedding Photojournalism

Andy Marcus

Learn the art of dramatic unposed wedding portraits. Working through the wedding from start to finish you'll learn where to be, what to look for and how to capture it on film. A hot technique for contemporary wedding albums! $29.95 list, 8½x11, 128p, order no. 1656.

Studio Portrait Photography of Children and Babies

Marilyn Sholin

Learn to work with the youngest portrait clients to create images that will be treasured for years to come. Includes tips for working with kids at every developmental stage, from infant to pre-schooler. Features: lighting, posing and much more! $29.95 list, 8½x11, 128p, order no. 1657.

Professional Secrets of Wedding Photography

Douglas Allen Box

Sixty portraits are individually analyzed to teach you the art of professional wedding portraiture. Lighting diagrams, posing information and technical specs are included for every image. $29.95 list, 8½x11, 128p, order no. 1658.

Photo Retouching with Adobe® Photoshop®

Gwen Lute

Designed for photographers, this manual teaches every phase of the process, from scanning to final output. Learn to restore damaged photos, correct imperfections, create realistic composite images and correct for dazzling color. $29.95 list, 8½x11, 120p, order no. 1660.

Creative Lighting Techniques for Studio Photographers

Dave Montizambert

Master studio lighting and gain complete creative control over your images. Whether you are shooting portraits, cars, table-top or any other subject, Dave Montizambert teaches you the skills you need to confidently create with light. $29.95 list, 8½x11, 120p, order no. 1666.

Storytelling Wedding Photography

Barbara Box

Barbara and her husband shoot as a team at weddings. Here, she shows you how to create outstanding candids (which are her specialty), and combine them with formal portraits (her husband's specialty) to create a unique wedding album. $29.95 list, 8½x11, 128p, order no. 1667.

Fine Art Children's Photography

Doris Carol Doyle

Learn to create fine art portraits of children in black & white. Included is information on: posing, lighting for studio portraits, shooting on location, clothing selection, working with kids and parents, and much more! $29.95 list, 8½x11, 128p, order no. 1668.

Infrared Portrait Photography

Richard Beitzel

Discover the unique beauty of infrared portraits, and learn to create them yourself. Included is information on: shooting with infrared, selecting subjects and settings, filtration, lighting, and much more! $29.95 list, 8½x11, 128p, order no. 1669.

Black & White Photography for 35mm

Richard Mizdal

A guide to shooting and darkroom techniques! Perfect for beginning or intermediate photographers who wants to improve their skills. Features helpful illustrations and exercises to make every concept clear and easy to follow. $29.95 list, 8½x11, 128p, order no. 1670.

Professional Secrets of Nature Photography

Judy Holmes

Improve your nature photography with this must-have book. Covers every aspect of making top-quality images, from selecting the right equipment, to choosing the best subjects, to shooting techniques for professional results every time. $29.95 list, 8½x11, 120p, order no. 1682.

Macro and Close-up Photography Handbook

Stan Sholik

Learn to get close and capture breathtaking images of small subjects – flowers, stamps, jewelry, insects, etc. Designed with the 35mm shooter in mind, this is a comprehensive manual full of step-by-step techniques. $29.95 list, 8½x11, 120p, order no. 1686.

Infrared Wedding Photography

Patrick Rice, Barbara Rice & Travis HIll

Step-by-step techniques for adding the dreamy look of black & white infrared to your wedding portraiture. Capture the fantasy of the wedding with unique ethereal portraits your clients will love! $29.95 list, 8½x11, 128p, order no. 1681.

Dramatic Black & White Photography:
Shooting and Darkroom Techniques

J.D. Hayward

Create dramatic fine-art images and portraits with the master b&w techniques in this book. From outstanding lighting techniques to top-notch, creative darkroom work, this book takes b&w to the next level! $29.95 list, 8½x11, 128p, order no. 1687.

Studio Portrait Photography in Black & White

David Derex

From concept to presentation, you'll learn how to select clothes, create beautiful lighting, prop and pose top-quality black & white portraits in the studio. $29.95 list, 8½x11, 128p, order no. 1689.